IMAGES
of America

PORTLAND'S
MARITIME HISTORY

On you 92nd
birthday!
keep the steam up!
Love you, dad!
Rusty

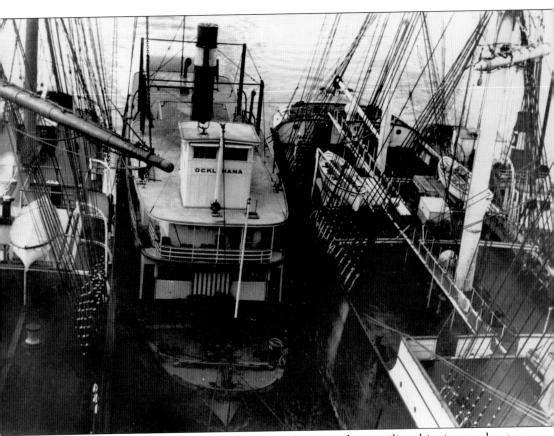

Here is the steam sternwheeler, the *Ocklahama*, under way with two sailing ships in a tandem tow on the Columbia River in 1915. In 1875, the Buchanan brothers, who were steamboat pioneers in Portland, began the construction of the first sternwheel steamer built solely for towing purposes, the *Ocklahama*. She was 152 feet long and 582 gross tons. Before she was completed, the Willamette Transportation and Locks Company, looking for possible crafts to compete with the People's Transportation Line, bought her and finalized her hull. The *Ocklahama* towed more vessels in her time than any other boat on the river. By 1894, she was in need of being fully restored. Her rebuild made her virtually new from keel to hog chain. She returned to work in 1897, still carrying *Ocklahama* as her name. In 1930, when the towing business had declined, she was abandoned. (Courtesy of Oregon Maritime Museum.)

ON THE COVER: The G.W. *Shaver* was one of the steamers built to work on both the Columbia and Willamette Rivers. She was launched in 1889 at Portland for the People's Trading Company, the name under which the Shaver Transportation Company was operating at that time. The *Sarah Dixon*, a wooden sternwheel-driven steamer launched in 1891, was one of the finest passenger boats on the river. The vessels were named after George Washington Shaver, founder of Shaver Transportation, and his wife, Sarah. (Courtesy of Shaver Transportation.)

IMAGES
of America

PORTLAND'S
MARITIME HISTORY

To your 9·2nd
birthday!

Rebecca Harrison and Daniel Cowan

ARCADIA
PUBLISHING

Published by Arcadia Publishing
Charleston, South Carolina

Printed in the United States of America

Library of Congress Control Number: 2013939467

For all general information, please contact Arcadia Publishing:
Telephone 843-853-2070
Fax 843-853-0044
E-mail sales@arcadiapublishing.com
For customer service and orders:
Toll-Free 1-888-313-2665

Visit us on the Internet at www.arcadiapublishing.com

*For the Oregon Maritime Museum's volunteers who
keep our history alive and available, as well as to all who
step onto the steam sternwheeler, the* Portland.

CONTENTS

ACKNOWLEDGMENTS

This project was initiated by the Oregon Maritime Museum, which also opened its vast library to us. We deeply appreciate the Portland maritime companies who have allowed us access to their historical archives: Fred Devine Diving and Salvage Company, Shaver Transportation Company, Vigor Industrial, and Zidell Marine Corporation. We also thank Dave Hegeman of the Oregon State Library for his assistance. Herb Beals, author and historian, pointed us in the proper direction more than once. We owe special gratitude to Peter Marsh, maritime journalist and overall global adventurer, who loaned his Larry Barber photograph collection for the duration of this endeavor. In that respect, we must also acknowledge Larry Barber for his collection and Elizabeth Barber for releasing it to Marsh.

INTRODUCTION

In 1843, a settlement called Oregon Country developed along the Willamette River. The name *Portland* was chosen for the town in 1845, and on February 8, 1851, the city was incorporated. Portland continued to grow and spread out after the Civil War, building docks for the shipment of lumber, fish, wheat, and produce to San Francisco and the rest of the world. Landowners wanted better roads to haul their goods to Portland for shipment, as the rivers soon became Portland's main thoroughfare.

Up to 1848, the yearly arrivals of vessels along the Columbia River had numbered just three to eight. By 1849, there were more than 50 ships berthing along the riverfront. The shore of the Willamette in Portland was populated with all kinds of traders; docks and warehouses were in great demand. In 1849, Capt. John H. Couch, in partnership with his brother-in-law, Capt. George H. Flanders, opened the first regular shipping business in Portland. The *Preston*, dispatched by Couch & Co., was the first ship to sail from Portland to China.

Portland was the major port throughout the Pacific Northwest until the 1890s, when the railroads were able to run from the harbors up north in Seattle, Washington, and points east by way of the Stampede Pass. Supplies and commodities could then be transported from the northwest coast to inland towns without the need to navigate the dangerous bar at the mouth of the Columbia River.

Portland worked hard to entice more businesses and families to live in its town. In 1905, Portland held the Lewis and Clark Centennial Exposition, a world's fair. This experience increased the recognition of the city, which caused its population to double, from 90,426 in 1900 to 207,214 in 1910. In 1915, the city merged with Linnton and St. Johns. Still, the rivers were Portland's water highway.

The old sight of cargo and passenger vessels traveling along the rivers in Portland was, and still is, familiar along the banks. Before 1950, it was common to witness a puffing sternwheel steamboat guiding a barge loaded with logs, lumber, pulp, paper, sawdust, sand, or gravel or perhaps towing a two-block-long raft of sawlogs under the opening frame of the Hawthorne Bridge.

Too soon for many steamboat pilots came the podgy and mechanically loud steel diesel tugs, replacing the sternwheelers with the need for fewer crewmen. They usually were not as powerful or strong in the water and couldn't tow as fast, but they managed to get there at a lower price. With these new ships came the creation of bigger and busier shipyards. As the wooden frames rotted away, new structures were built with steel, aluminum, and fiberglass.

One of the oldest and last-standing wooden shipyards in Oregon was the Portland Shipbuilding Co., often known as the South Portland Shipyard. Here, many sternwheel steamers were built or rebuilt, including the *Bailey Gatzert, Beaver, Claire, Dalles City, Georgie Burton, Henderson, Joseph Kellogg, N.R. Lang, Sarah Dixon, Shaver,* and *Umatilla*. The last northwest sternwheeler the Portland Shipbuilding Co. built here was in 1919; they repaired other crafts until 1926 and then made more than a mile of vessels for the Navy, Army, and Marine commission during

World War II. This shipyard stayed active until 1964, repairing and renting wooden barges; the Portland Shipbuilding Co.'s original building still stands on Southwest Nebraska Street, facing the Willamette River in downtown Portland.

The Kaiser Shipyards, owned by the Kaiser Shipbuilding Company founded by Henry Kaiser, comprised seven major shipbuilding yards on the West Coast. By 1939, these shipyards were active in meeting the construction needs for merchant shipping. One of the seven yards was the Oregon Shipbuilding Company; another was the Swan Island Shipyard located on Swan Island.

During World War II, there was a profound need for war supplies. Since Portland was located at the union of two major rivers, it was an ideal place for establishing factories to manufacture military supplies. The Oregon Shipbuilding Corporation was developed just to build Liberty and Victory ships from 1941 until 1945. Among the vessels built there was the Liberty ship *Star of Oregon*, which was launched on September 27, 1941; it was the first of the 472 ships built by the company. Overall, these shipyards produced 1,490 ships, 27 percent of which were slated for the Maritime Commission. Kaiser Shipyards shut down at the end of World War II. (The former site of the Oregon Shipbuilding Co. is now Schnitzer Steel Industries.)

On September 2, 1945, after the surrender of Japan, Fred Devine, a salvage and construction diver for the Kaiser shipyards, told his boss to keep his extra earnings safely in his account until he could use it to purchase a ship that fit into his plans for the perfect salvage tug.

In 1948, the government was unloading much of its wartime fleet at scrap prices, far below their original cost. Devine heard about a series of LSM (Landing Ship, Medium) vessels that were available in San Francisco; they were 203 feet long, 34 feet wide, and had a draft of 9 feet. Devine bought one of the ships and spent all his money converting it into his dream tug. He docked his liner at the Consolidated Builders Inc. facilities on Swan Island, which was a Kaiser subsidiary that continued to repair and modify ships. He worked with the company to convert the liner into his vision of a salvager, adding many vital features. By using his credit with Consolidated Builders, Devine scrounged and foraged through other vessels for much of the necessary equipment for this ship, which he would name the *Salvage Chief*. With the success of his new salvager ship, Devine opened his own company on a six-acre site with river frontage and dockage on the Swan Island Lagoon in Portland. Soon, many moorages, fishing boats, and maritime businesses were booming all along the river shores.

Such has been the growth of Portland shipping, which is now among the great ports of the country. Today, at the Port of Portland's five marine terminals, container ships, grain ships, bulk and break-bulk carriers, and auto carriers work around the clock. The Port of Portland leads the nation in wheat exports and is ranked fourth in the nation for auto imports. Also, barges work the Columbia and Snake Rivers system, the second-largest waterway in the nation, feeding the port's Terminal 6 from as far upriver as Lewiston, Idaho, more than 300 river miles away. Foreign Trade Zone No. 45, administered by the Port of Portland, provides an additional incentive for international trade activity.

One

THE STEAMERS

The powerful Columbia River is some 2,000 miles long, making it the second-longest river in the United States. This river was a challenge for the first explorers of the northwest, as it is rough with over 100 areas of rapids, reefs, bars, and strong currents. Moving downstream was fairly easy, but the white water and occasional falls made it virtually impossible to establish any upstream travel with sailing ships or canoes. Even so, in 1805, the well-known explorers Meriwether Lewis and William Clark put their canoes into the Columbia.

Portland, Oregon, is located on the Willamette River, approximately 10 miles upstream from the Willamette's confluence with the Columbia. Historians are unsure as to when Portland was first founded. Records show a settler may have established what was later called East Portland in 1829. By 1842, William Johnson of Captain Couch's brig *Maryland* staked his claim on the west side of the Willamette River and built a small cabin. Tennessee drifter William Overton and Boston lawyer Asa Lawrence Lovejoy settled in Portland in November 1843 while on their way from Fort Vancouver to Oregon City.

During this time, the sounds of steam whistles resounded across the water, framing the power of the mighty rivers. Steamers offered one of the most efficient means of transportation for those traveling in the Pacific Northwest region. As more people came to explore and settle in the Portland area, many steamboats worked on both the Columbia and Willamette Rivers.

Steamboats were the most common types of crafts used in the 1850s, which allowed for the rapid expansion of Portland, bringing in and carrying out people, commodities, and supplies. These steamers included propellers, paddlewheelers, sidewheelers, and sternwheelers. The paddlewheelers were easier to maneuver through the winding rivers and could land nearly anywhere. For this reason, these boats became more dominant in the area.

Many vessels operated on the rivers along Portland. Those pictured in this chapter are just a few examples of the steamers that traveled in and out of Portland's harbor.

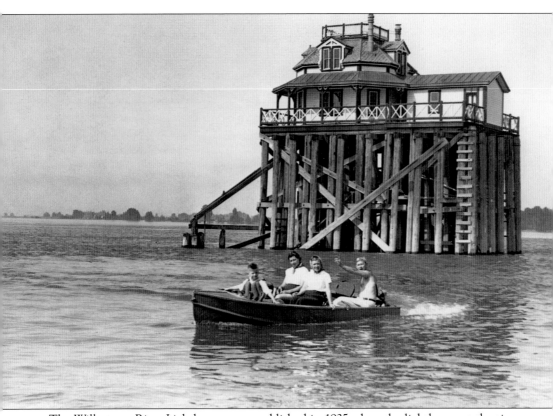

The Willamette River Lighthouse was established in 1935 when the lighthouse at the time was disabled. The newly electrified light and bell were moved to the end of a dike to illuminate the junction of the Willamette and Columbia Rivers, near the eastern side of the entrance to the river at Kelly Point. The light was displayed from a house painted with black and red horizontal bands, on a collection of pilings 24 feet above the surface of the water. A fog signal was sounded on an electric bell; the signal was not sounded from June 1 to August 31. A 1959 chart does not feature the lighthouse, but the bell marking is still present. This was the home of the lookout who reported arrivals of ships at the mouth of the Willamette, about 10 miles below Portland. (Courtesy of Peter Marsh.)

Capt. Lewis Love was born in Chautauqua, New York, in 1818. He left Missouri with his wife, seven children, and a three-family wagon train in the spring of 1849 for the Oregon Country. In 1850, Captain Love moved his family to a log cabin on the Columbia Slough. As he felled logs from the vast forests of his 635-acre Donation Land Claim, he rolled them into the slough, then towed them to a sawmill in Portland. The trail from the ferry landing at East Portland to the Columbia River ferry to Port Vancouver passed Captain Love's cabin, so he built a ferry to carry travelers and their livestock across the slough, charging a small fee. One of his frequent customers was Capt. Ulysses S. Grant, then stationed at Fort Vancouver. From 1862, Captain Love and two partners built the steamboats *E.D. Baker*, *Irisi*, and *Kiyus*. These boats worked the Columbia River around Portland. By the time of his death in 1903, Captain Love became one of Oregon's first millionaires from his sawmills, gristmills, and steamboats. (Courtesy of Peter Marsh.)

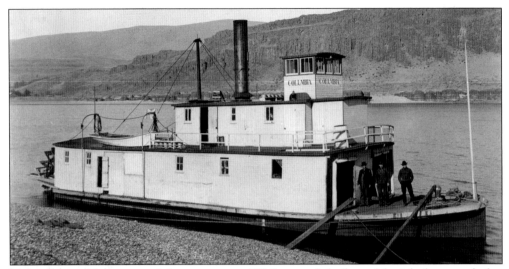

Many ships and boats carried the same name. While a newly built model might be named after a famed predecessor, often the original was still in service. Sternwheelers, freighters, tugs, and yachts continue to share their heraldry with no relation to their type. In this case, a small ferry named *Columbia* could be confused with a sidewheeler, three other larger sternwheelers, and even a modern diesel tug. (Courtesy of Peter Marsh.)

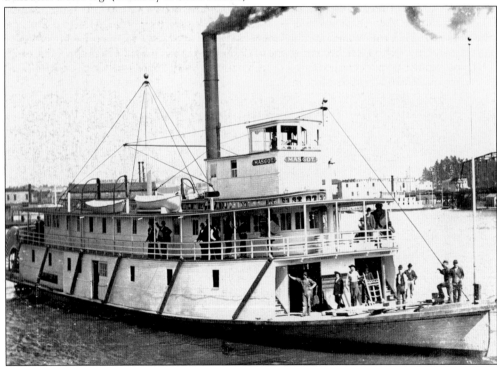

The sternwheeler *Mascot* was built in Portland in 1890 to 132 feet in length and 267 gross tons. She was rebuilt in 1908, extending her length by nine feet and her weight by another 32 tons. A 1911 fire from a fuel oil explosion burned her to the water near Woodland, Washington. Steward Sydney Illidge lost his life. The *Mascot* and her cargo were a complete loss. (Courtesy of Shaver Transportation.)

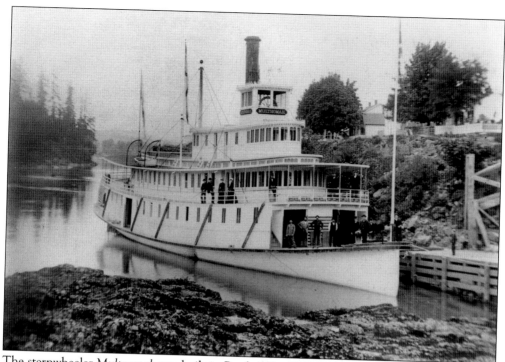

The sternwheeler *Multnomah* was built in Portland in 1855 for the Portland–Oregon City run. She worked on both the Willamette and Columbia Rivers until 1889, then was later relocated to Puget Sound in Washington, becoming one of the better-known sternwheelers. On October 28, 1911, the steamer *Iroquois* crashed into her in Elliot Bay, Washington, where she sank 240 feet. (Courtesy of Oregon Maritime Museum.)

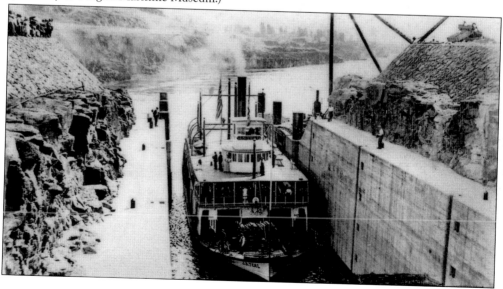

The sternwheeler *J.N. Teal* was built in Portland in 1907 to carry freight and passengers from Portland to Big Eddy, Oregon, past the Celilo Locks. She burned her first year and had to be completely rebuilt. The *Teal* spent her last years working for the Willamette and Columbia Towing Company. She was abandoned in 1937 and later dismantled. (Courtesy of Oregon Maritime Museum.)

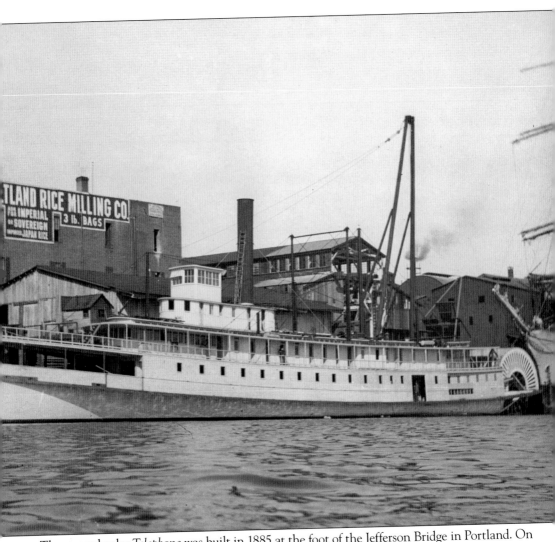

The sternwheeler *Telephone* was built in 1885 at the foot of the Jefferson Bridge in Portland. On November 12, 1887, the *Telephone* caught fire from an oil backfire in the boiler just as she was coming into Astoria. She was towed back to Portland and rebuilt, returning to work in 1888. In 1892, she sank near the mouth of the Willamette River. She was raised and restored and worked until 1903, when her engines were removed for a new *Telephone*. This steamer was built in 1903, and with the exception of three summer months of 1905, she never worked. During those years, she was a landmark at the Haseltine dock on the east side of Portland. She was 202 feet long with a 31.5-foot beam, 8-foot hold, and 794 gross tons. She was known then to be the fastest sternwheeler afloat. In 1907, she was chartered to the Regulator Line and worked between Portland and The Dalles. In 1909, she was sent to San Francisco to work until her last days on the water. (Courtesy of Shaver Transportation.)

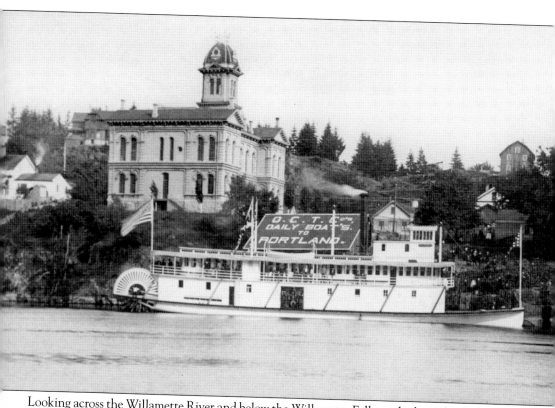

Looking across the Willamette River and below the Willamette Falls, at the lower level of Oregon City is the steamer *Altona*, waiting by the 8th Street Dock, next to the Clackamas County Courthouse (built in 1884) on Main Street. (There were two docks in Oregon City: the 8th Street Dock and, near the mills, the 4th Street Dock.) The sign painted on the roof of the steamboat terminal—O. C. T. Co.'s DAILY BOATS TO PORTLAND—belonged to the Oregon City Transportation Company. The sternwheeler *Altona* was built in 1890 in Portland and worked on the Willamette River until 1907. She was driven by twin single-cylinder, horizontally mounted steam engines. In 1899, the *Altona* was rebuilt in Portland and enlarged from 201 to 329 gross tons and from 120 to 123 feet in length. The steamer was owned by the OCTC, which named all its boats with the *–ona* suffix: *Latona, Ramona, Leona, Altona, Pomona, Oregona,* and *Grahamona.* In 1908, the *Altona* was taken up to Cordova, Alaska, to work with the railroads. (Courtesy of Peter Marsh.)

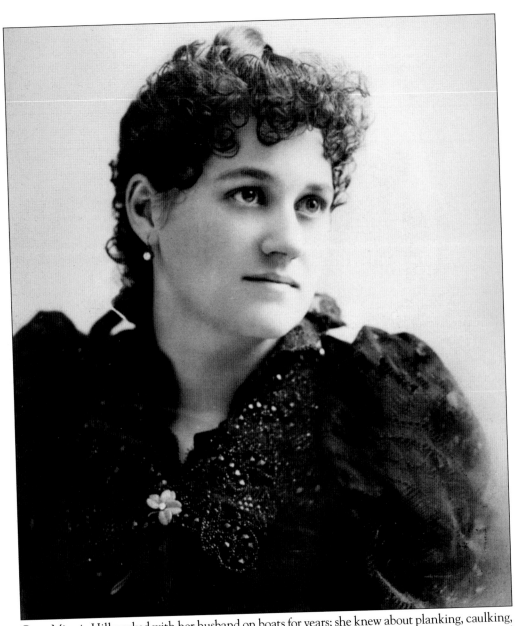

Capt. Minnie Hill worked with her husband on boats for years; she knew about planking, caulking, boiler firing, engine controls, and the skills of navigation and piloting. She began studying and eventually mastering the craft of piloting steamboats. The testing was extremely difficult for her, as the examiners wanted to refuse her a license without justification. She earned her master's license to operate steamboats on December 1, 1886. She was the first licensed woman to command a steamer on the Columbia River; she remained so until 1907. She worked along the harbor in Portland, delivering goods and farm products between the settlers and the city. The floating market was successful for several years. Crowds would wait to watch the beautiful female captain dock her boat. Captain Hill operated the *Governor Newell* for 14 years while her husband, Capt. Charles Hill, took charge as engineer. During this time, Captain Hill gave birth to two children, but only one survived. When her boat became too worn to use, Captain Hill retired. (Courtesy of the Oregon State Library.)

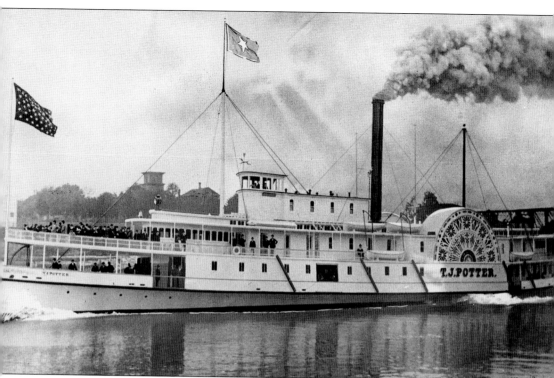

The *T.J. Potter* was a sidewheeler that was launched in Portland in 1888. Her upper cabins came from the steamboat *Wide West*. This required some modification because the *Potter* was a sidewheeler, while the *Wide West* had been a sternwheeler. The *Potter* was one of the few sidewheelers that operated on the Columbia River. She was built for the Oregon Railway and Navigation Company. When built, the *Potter* had a reputation as one of the fastest and most luxurious steamboats in the Pacific Northwest. The *Potter* was removed as a tourist boat in 1916; she then served as a barracks boat for construction crews until November 20, 1920, when her license was revoked, leaving her abandoned on Young's Bay near Astoria; there, she was salvaged for her metal. The *Potter* has deteriorated over the past years. All that remains are mostly parts of the ribs as well as the keel. The starboard paddle box is still intact, but it is believed that the wheels have been removed. (Courtesy of Oregon Maritime Museum.)

Here are working sternwheelers guiding ships along the Willamette River and under the Burnside and Broadway Bridges. Both of these overpasses are bascule bridges. *Bascule* is a French term for "seesaw and balance." A bascule bridge (sometimes called a drawbridge) is a viaduct that can move, or open, with a counterweight that continuously balances the span, or "leaf," during the entire upward swing for clearing water traffic. The Broadway Bridge was the first bascule design built in Portland. It was also the longest in the world at the time of its completion. Even today, it is still the longest Rall-type bascule. Both bridges were listed in the National Register of Historic Places in November 2012. (Both courtesy of Peter Marsh.)

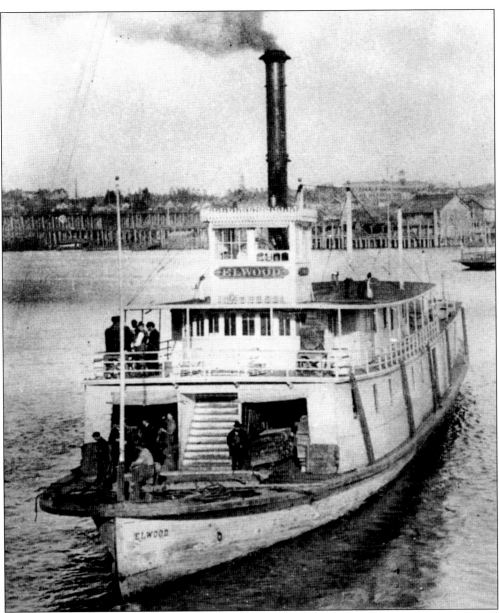

The sternwheeler *Elwood* carried both freight and passengers on the Willamette River over 120 years ago. She was built in Portland in 1891 for Abernethy & Co., which commissioned her under Capt. J.L. Smith, followed by Captains R. Young and James Lee. She was 154 feet long with a 30-foot beam, 4-foot hold, 510 gross tons, and 72-by-12-inch engines. She is best remembered for her rescue in November 1893. An inbound trolley traveling from Sellwood on the Madison Street Bridge rolled off the open side, and the *Elwood* saved 20 of its passengers. In 1894, she was bought by the Lewis River Transportation Company, which was located on the Lewis River, a tributary of the Columbia River, just below the city of Vancouver, Washington. In 1898, she was transferred to work up north in Alaska. (Courtesy of Shaver Transportation.)

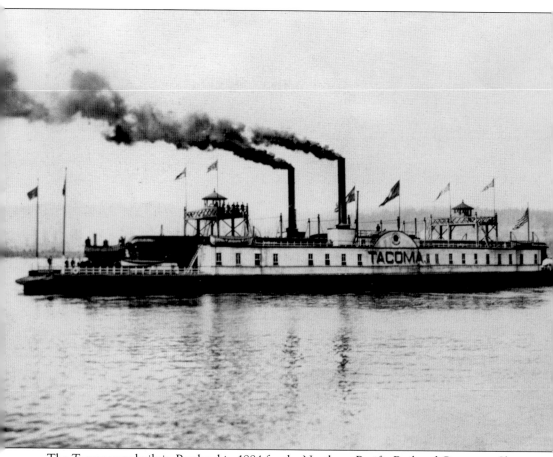

The *Tacoma* was built in Portland in 1884 for the Northern Pacific Railroad Company. She was a passenger and freight steam sidewheeler ferry. Mostly, she was used to ferry trains from Kalama, Washington, on the Columbia River to various ports in Oregon. She was 1,362 gross tons with a 334 foot length, 42 foot beam, and an 11-foot-7-inch draft. She had two 500-horsepower steam engines and two iron side paddles that were each 29 feet high. She had a weight capacity of 23 freight cars and two engines, or 15 passenger coaches and two engines. The *Tacoma* was supplied with 978 feet of rail track on board, along with a crew of 37 men. Portland was her home port. She made her last run on December 25, 1908. In 1916, she was transferred to Puget Sound, Washington, and converted into a barge named *Barge No. 6*. On January 12, 1950, she collided with a ship and sank. Seattle's Elliot Bay became the old *Tacoma's* final resting place. (Courtesy of Oregon Maritime Museum.)

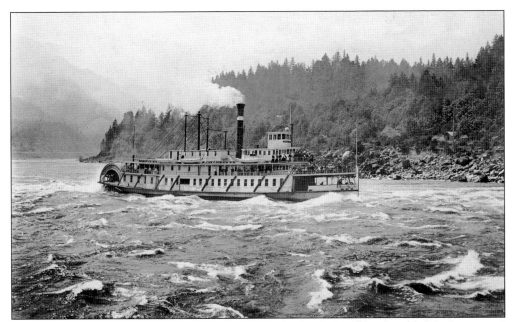

The *Bailey Gatzert* was built in 1890, arriving in Portland in 1892. She was one of the largest and fastest sternwheelers around. She was also the first wood-fueled steamer built to carry passengers, as previous vessels working the Columbia River Gorge were built mainly for freight. She ran routes from Portland around the state until 1907. (Courtesy of Peter Marsh.)

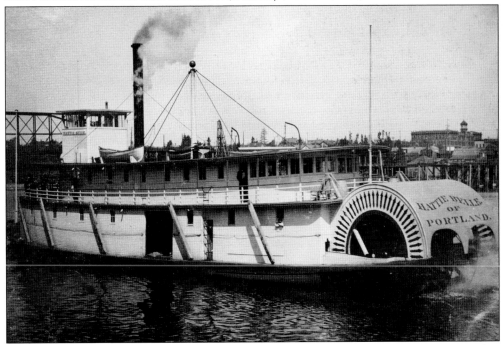

The sternwheeler *Hattie Belle* was built in Portland by Capt. M.A. Hackett in 1892. He ran her as a towboat until 1894; she was then sold for use on the Cascade route with the steamer *Ione*. The *Hattie Belle* was only 110 feet in length, with a 24-foot beam, a 4.5-foot hold, and just 561 gross tons. She was dismantled in 1906. (Courtesy of Shaver Transportation.)

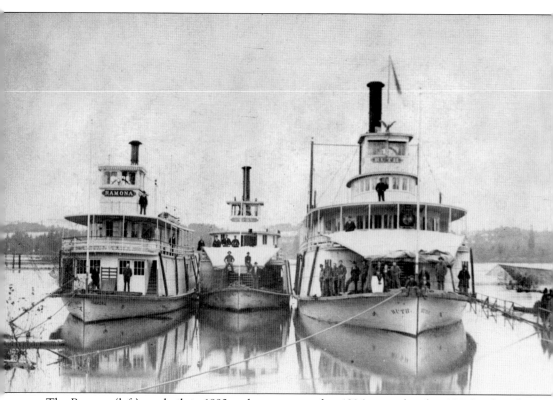

The *Ramona* (left) was built in 1892 and reconstructed in 1896, extending her 100-foot length to 118 feet. The *Ramona* was specially fitted for passenger service and was reported to have the best cabins of any steamer operating on the Willamette River. She was transferred to British Columbia in 1898 and sank on April 22, 1908, at Wharton's Landing near the mouth of the Harrison River. The *Gypsy* (center) was built in 1895 and was wrecked and put out of service in 1900. The *Ruth* (right) was built in 1895 and worked until 1917 on the Willamette River. The *Ruth* played an important role in the transport of goods and agriculture in Oregon; she was one of the fastest steamboats ever to operate on the upper Willamette. On March 31, 1917, the stern of a newly launched all-steel vessel, the *Vesterlide*, struck the *Ruth*. Three of her crew were injured, and the *Ruth* sank from this collision. (Courtesy of Peter Marsh.)

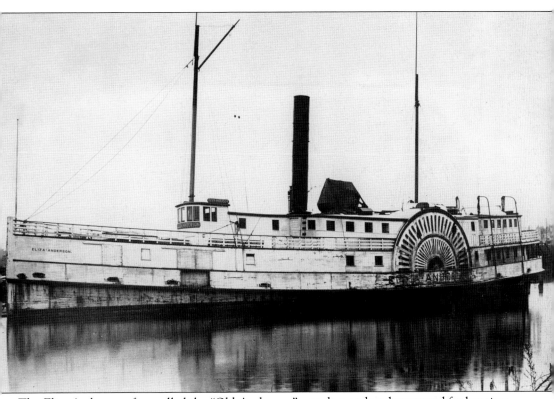

The *Eliza Anderson*, often called the "Old Anderson," was slow and underpowered for her time. She was launched on November 27, 1858, in Portland for the Columbia River Steam Navigation Company. She was a sidewheeler, driven by a low-pressure boiler generating steam for a single-cylinder, walking-beam steam engine. She was made entirely of wood, weighing 276 tons and measuring 197 feet in length with a 25.5-foot beam. While she is shown here mooring in Portland (possibly for repairs, as her walking beam is covered and anchor chain is run up to the log boom, suggesting she was laid up at the time of this photograph), she mostly worked out of Puget Sound, Washington. In 1897, the Yukon Transportation Company purchased her and sent her north to Alaska. In 1898, at Dutch Harbor, following a steam pipe explosion and collision with a dock, the *Anderson* was abandoned by her passengers, who were safely transferred to a steam schooner. There, after working for 40 years, she was hit by a storm, beached, and left to rot away. (Courtesy of Oregon Maritime Museum.)

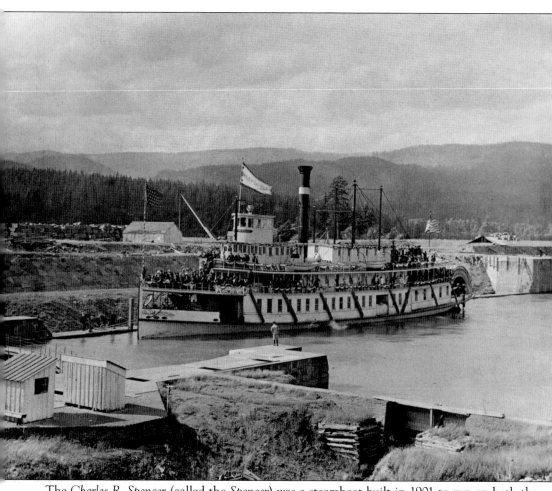

The *Charles R. Spencer* (called the *Spencer*) was a steamboat built in 1901 to run on both the Willamette and Columbia Rivers from Portland to The Dalles. The *Spencer* was considered one of the elite vessels of its time. She had a bright-red smokestack and a steam whistle so loud it was said that when she blew, it shook the piles along the river. Although steamboat racing was technically illegal, operators of steamboats often tried to "do their best" when a rival steamboat was on the river. Since the *Spencer* was a graceful boat, it frequently raced against other top vessels of the day, including the *Bailey Gatzert* and the *T.J. Potter*. Races against the *Bailey Gatzert* happened almost every day when the two vessels ran against each other on the Portland–The Dalles route. The rising automobile business took away the *Spencer*'s main routes, and in 1911, the vessel was rebuilt and renamed the *Monarch*. The *Spencer* was transferred to California in 1914. (Courtesy of Shaver Transportation.)

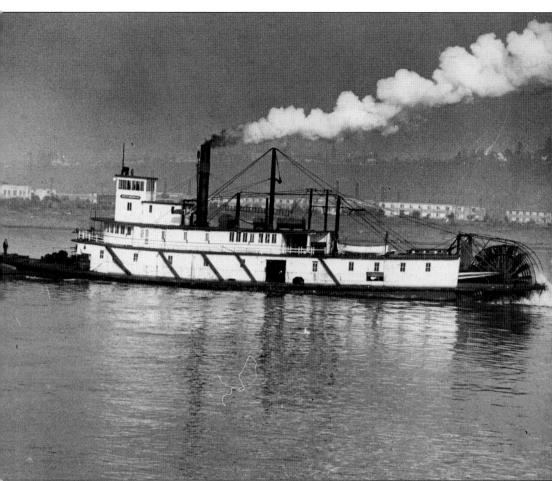

The M.F. *Henderson* was the first limited freight and towing rig built for the Shaver Transportation Company. She was built at the Portland Shipbuilding Co. in 1902, costing $32,350. She was christened after M.F. Henderson, the vice president and general manager of the Eastern & Western Lumber Company. She was nearly 160 feet in length with a 31-foot beam and 7.5-foot hold. Her engines had an 18-inch diameter with an 84-inch stroke and were built by the Portland Iron Works. These engines were believed to be the first piston-valve sternwheel engines ever made on the Columbia River with a rotary cutoff. The Portland Boiler Works built her boiler. She worked on the Clatskanie run, carrying lumber and shingles from Clatskanie to Portland, often towing one or more rafts on the same trip. On her return, she would haul canned goods, feed, and materials to the lower river, making stops at Rainer, Oak Point, Stella, and other harbors. During an overhaul, she lost the initials M.F. and became the *Henderson*. (Courtesy of Shaver Transportation.)

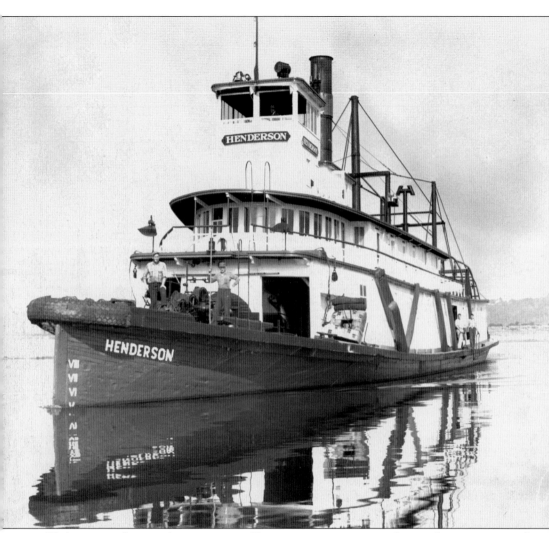

With a crew of over a dozen men in addition to its insurance and general maintenance, the *Henderson*'s operating cost in 1902 was $64 a day. In 1911, while towing a Standard Oil barge from Astoria to the Columbia River jetty in Portland, she collided with a barge at a basin in Clatsop County, Oregon, called Bugby Hole. She sank and rolled over; the crew was able to scramble up on her side. When she turned over again, the crew crawled through the gangway and climbed up the other side. It was said that the steamer's cook crawled through the hawsepipe and was put aboard the Standard Oil barge. In December 1956, with a grain ship in tow, the *Henderson* encountered heavy swells near the mouth of the Columbia River. The vessel's hull pounded against the unyielding tow, and the crew was forced to beach her near Columbia City. Declared a "constructive total loss," she was left on the shore until she was burned to salvage scrap metal in 1964. (Courtesy of Peter Marsh.)

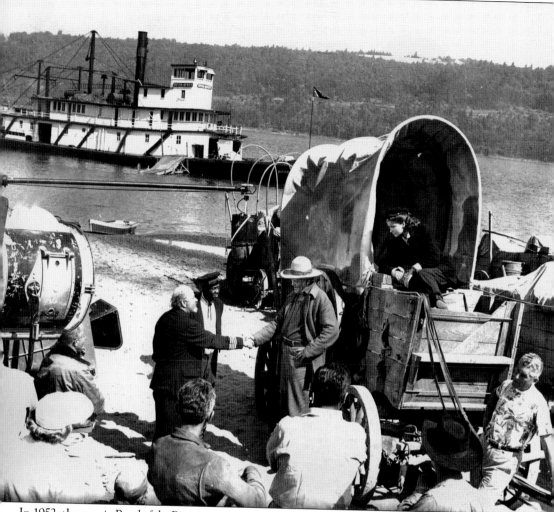

In 1952, the movie *Bend of the River*, starring actors James Stewart, Arthur Kennedy, Rock Hudson, J.C. Flipin, Julia Adams, and several others plus about 50 local extras was filmed in Oregon. Some of the scenes took place on the Columbia River using the sternwheeler *Henderson*, which the Portland outfit Shaver Transportation Company chartered to Universal-International Pictures of Hollywood. In the movie, the steamer was outfitted and modified to represent a mid-1800s steamer and rebranded (temporarily) the *River Queen*. To change the appearance of the *Henderson* for filming, her towing winch on the forward deck, her official numbers on the bow, and her big searchlights on top of the pilothouse were all removed. The fuel oil filter pipe on the forward deck was concealed with old canvas and coils of rope. (Courtesy of Peter Marsh.)

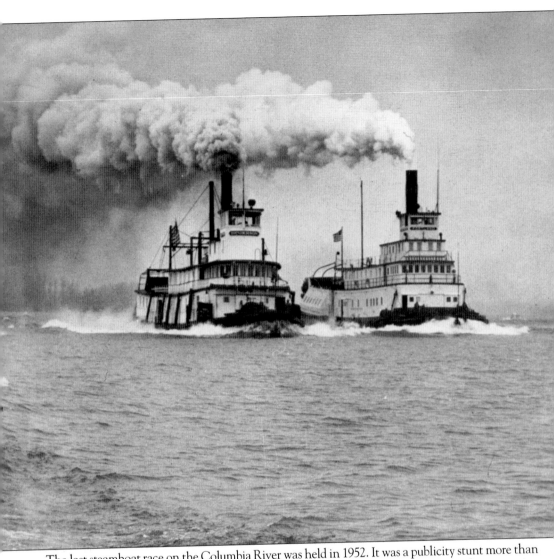

The last steamboat race on the Columbia River was held in 1952. It was a publicity stunt more than a real race between the sternwheelers *Henderson* and *Portland*. This race was set for the promotion of the release of the movie *Bend of the River*, which was filmed in Oregon. The two steamboats left from Portland, racing to the finish line at Rooster Rock, Oregon, on the Columbia River. The actor James Stewart and other members of the cast were on board the *Henderson*, which won the race but blew a gasket while doing so. Capt. Homer T. Shaver, who watched the race, said that both sternwheelers were running fast for their design as towboats, but the speeds were not much compared to what he had seen as a young man on the river. (Courtesy of Peter Marsh.)

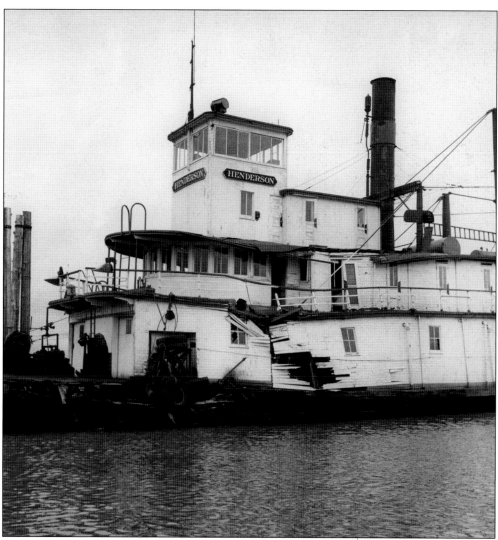

The *Henderson* was one of the last two wooden sternwheeler towboats still working for the Shaver Company in 1950. The other one on the Willamette and Columbia Rivers suffered serious damage in December 1950. While assisting the *Chinook*, a steel diesel tug moving the decommissioned freighter *Pierre Victory* from Portland to Astoria, the *Henderson* went too fast to the steamship's starboard side and was pushed over submerged pilings of a Cottonwood Island dike. The moving ship dragged her across the sunken snags, tearing a 20-foot hole in her wooden hull. The towline was cast off and Capt. Sidney Harris, pilot Don Weik, and the rest of the *Henderson*'s crew began to diligently try to save their boat. Within seven minutes, the quickly sinking sternwheeler reached sheltered water at the foot of the island and was beached. The wide hole was later repaired and her hull pumped out, and she was able to return on her own to Portland. (Courtesy of Peter Marsh.)

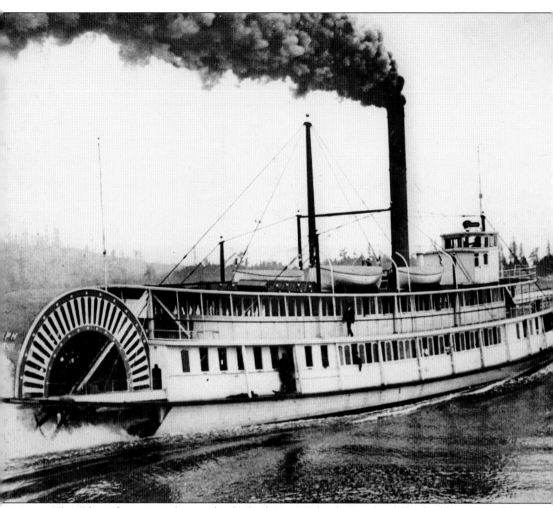

The *Telegraph* was a steel sternwheeler built in 1903 by the Portland Shipbuilding Co. in Everett, Washington; at the time, she was considered the fastest sternwheeler in the world. She registered 386 tons with dimensions of 153.7 feet by 25.7 feet by 8 feet. The sternwheeler was placed under Capt. U.B. Scott of the Seattle-Everett Navigation Co. on the Seattle-Everett route to replace the steamer *Greyhound*. In 1910, the Puget Sound Navigation Co. bought the *Telegraph*, keeping her on the Seattle-Everett route. She worked in Portland for a time in the excursion business during and after the Lewis and Clark Exposition in 1905. On April 25, 1912, the Alaska Steamship Co. steel ship *Alameda* hurtled through the Colman Dock in Seattle, striking the *Telegraph* on the other side, almost cutting her in half; she sank within 15 minutes. Amazingly, there were no civilian casualties. (Courtesy of Peter Marsh.)

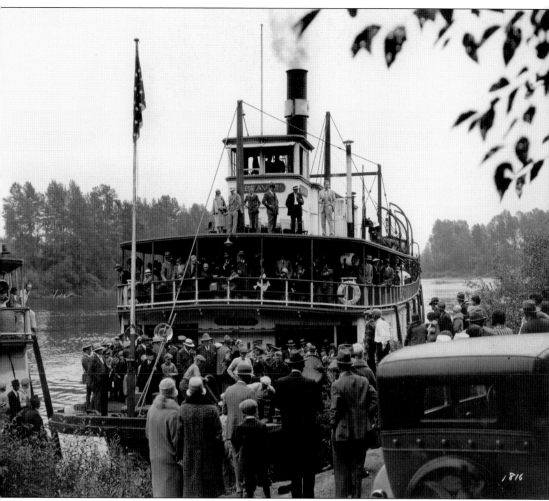

There were many steamboats that carried the *Beaver* name. This photograph shows the sternwheeler *Beaver*, which was originally named the *G.W. Shaver* and then the *Glenola*. Weighing in at 421 gross tons, she had been rebuilt in Portland in 1906 to a length of 152 feet with a 30-foot beam and 6-foot hold. Having a flat bottom allowed her to handle large cargos at low stages of water. She was sold to the Harkins Transportation Company and then to the Hosford Transportation Company, which worked her on the upper Columbia River after 1932. When the Shaver Company bought out that business in 1934, the *Beaver* continued working on the upper Columbia. In 1935, she struck a rock and sank near the Canoe Encampment Rapids on the upper Columbia River. (Courtesy of Shaver Transportation.)

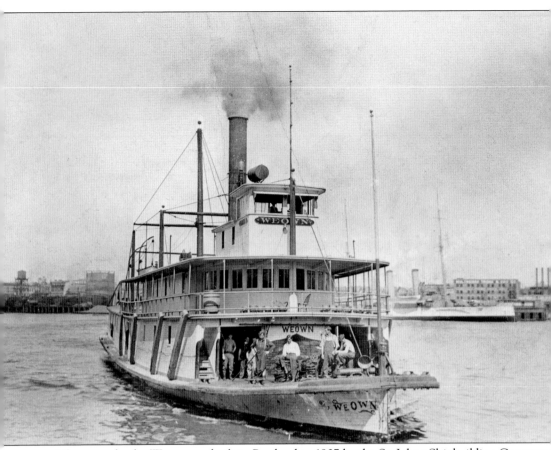

The sternwheeler *Weown* was built in Portland in 1907 by the St. Johns Shipbuilding Company yards for the Columbia and Cowlitz River Transportation Co. Her length was 153 feet at 372 gross tons. She had a beam of 31.5 feet, depth of 6.5 feet, and a draft of 4.5 feet. Her engines were 72 inches by 16 inches; they were shipped to Portland and then installed. Her firebox boiler was 225 pounds of steam pressure. She was launched in June 1907 and was used in towing logs on both the Columbia and Willamette Rivers. On June 17, 1933, the *Weown* became the last sternwheeler to run the Cascade Rapids. In February 1908, she was sold to Hosford Transportation Co. They used her until 1934, when the Shaver Transportation Co. bought her. After working the waters for four more years, the *Weown* was dismantled in 1936. (Courtesy of Peter Marsh.)

The 150-foot-long *Georgie Burton* was built in 1906 and was among the last surviving wooden steamboats on the Columbia River. She was rebuilt in 1923 as a Western Transportation Company towboat and was berthed in Portland. When departing, her whistle gave the traditional three-blast farewell to sentimental Portlanders who waited on the riverbank to watch her pass by. (Courtesy of Peter Marsh.)

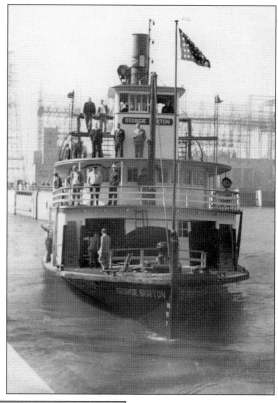

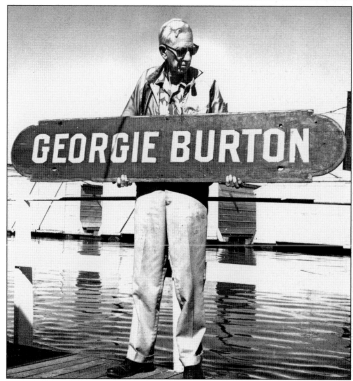

On March 20, 1947, the *Georgie Burton* embarked on what would be the final trip from Portland to The Dalles for this 41-year-old, steam-powered sternwheeler. She was moored in the Celilo Canal, near The Dalles. The Columbia River flood of 1948 knocked her loose and broke her back—a total loss. Here in 1972 is Larry Barber, the *Oregonian* newspaper photographer and writer, holding the *Georgie Burton*'s name board. (Courtesy of Peter Marsh.)

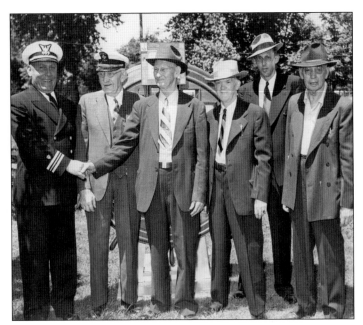

These crew members of the sternwheeler *Weown* were survivors of the last passage over the Cascade Rapids in the Columbia River. They are pictured meeting at the reunion of the Veteran Steamboatmen's Association of the West: (from left to right) Capt. W.F. Horats, master of the boat; Capt. Charles Nelson, pilot; John J. McBroom, chief engineer; J.W. Driscoll, assistant engineer; Knight Knowles, deckhand; and Luke Briggs, firefighter. (Courtesy of Peter Marsh.)

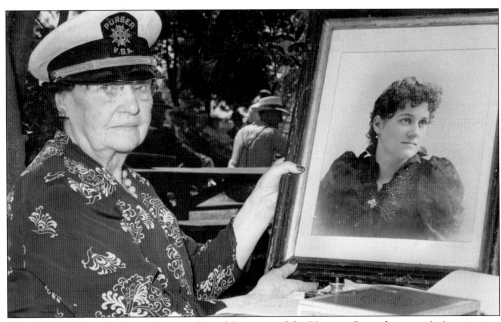

Purser Sara Riggs, who kept the records and finances of the Veteran Steamboatmen's Association (VSA), is shown here holding the portrait of Capt. Minnie Hill, who achieved fame many years ago as the Columbia River's first and only woman licensed as pilot and master. Riggs is the widow of the late Capt. Arthur Riggs, who headed the VSA for nearly 15 years. (Courtesy of Peter Marsh.)

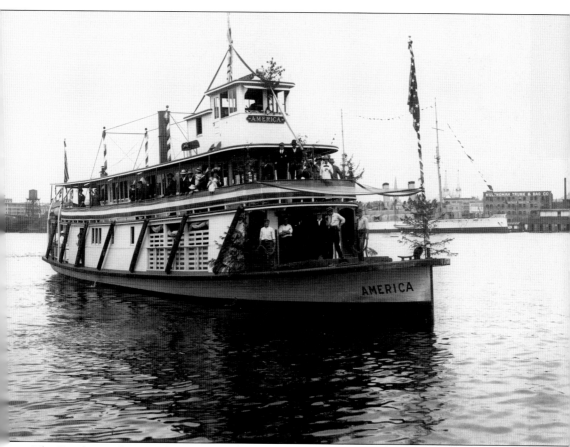

The Pacific Mail Steamship Company was the first steamship business to begin a westward transpacific steamship service to the Orient. Steamships of the Pacific Mail controlled the transpacific trade for a long time and continued for some 48 more years. The company's China line began with the wooden steamship *Colorado* on January 1, 1867. Others soon followed, which initiated successful, lengthy journeys from the Orient. Herbert H. Holmes built the 97-ton propeller passenger steamer *America* in Portland in 1912 for the America Transportation Co. At 105 feet in length with an 18.5-foot beam and 150-horsepower engine, she worked on the Portland-Astoria run with her crew of five men. In 1942, her engine was removed, and in 1946, she was burned at the mouth of the Willamette River. (Courtesy of Oregon Maritime Museum.)

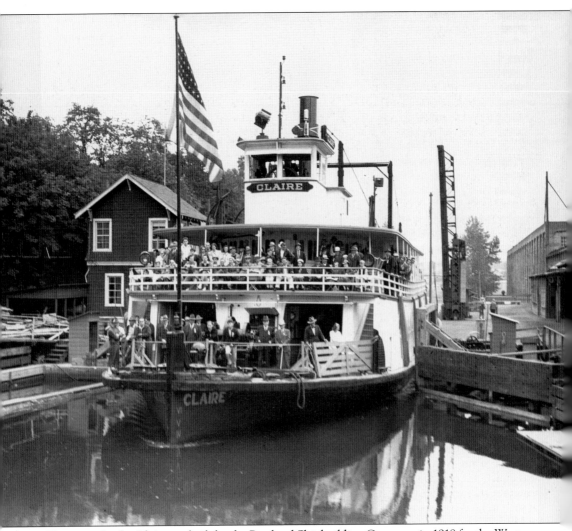

The sternwheeler *Claire* was built by the Portland Shipbuilding Company in 1918 for the Western Transportation Company. The *Claire* was 157 feet long, narrow, and 563 gross tons. She was built to tow log rafts and barges between the Crown Willamette Paper Company plant in West Linn, Oregon; the downtown Portland docks; and the Crown Zellerbach plant in Camas, Washington. Years later, she was relegated to barge pushing. The *Claire* was favored by the VSA, which borrowed her every year for their reunion. The retired veterans working as crew would load up for a 67-mile round trip from downtown Portland. The *Claire* made her last run on June 29, 1952. The president of Western Transportation Company had her engines and boilers removed and retired the *Claire* to the company moorage as a floating shop. Her hull and exteriors were kept intact. Her famous three-bell whistle was transferred to the steamer *Henderson*. Over the years, other pieces and equipment were removed. In 1961, the *Claire* was burned down on the water. (Courtesy of Peter Marsh.)

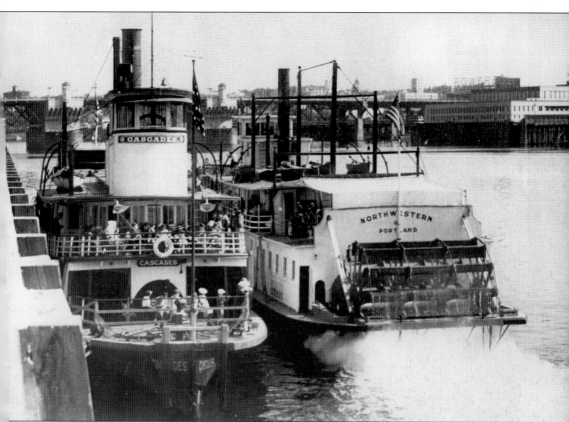

In August 1935, at Portland's harbor wall, two river steamer sternwheelers—the *Northwestern* and the *Cascades*—boarded 500 eager passengers for the 110-mile voyage from Portland to Bonneville and back. These sternwheelers were taking sightseers to a landing below Bonneville while the dam was under construction. The tickets had sold out, and it looked like the days before automobiles when the sternwheelers were one of the main modes of transportation. The *Northwestern*, renamed as such in 1920, was originally called the *Grahamona*. She was built in Portland in 1913 at a length of 149.5 feet, hold of 4 feet and 5 inches, and engines of 72 by 14 inches. The last sternwheeler on the upper Willamette River in passenger and freight service, she worked between Portland and Corvallis for the Oregon City Transportation Co. (Courtesy of Peter Marsh.)

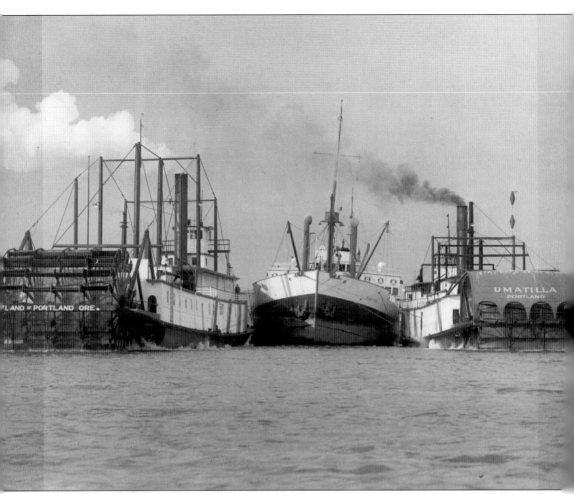

There have been three *Portland* steamers in Portland, Oregon. The second *Portland*, built in 1918 by the Port of Portland, was used as a towboat for docking and moving vessels within the Portland Harbor. She was invaluable for helping to move deep-draft ships through the Willamette River bridges during times of strong currents up to five mph and winds of 40–50 mph. Built for speed and proficiency, she was one of the largest and most powerful sternwheelers of her kind at 185 feet in length and 801 gross tons. Her wooden hull was long and narrow with a short cabin resting on top of the freight deck. Her Texas deck and pilothouse were at the bow. (Her uncovered stern wheel was very uncommon on the river during that time.) Here, she (at left) and the sternwheeler *Umatilla* (built in 1908 at Celilo, worked as a dredge for the US Army Corps of Engineers, rebuilt in 1928, and dismantled in 1942) are towing a half-sunken Italian freighter, the *Feltre*, to the Portland dry docks in 1937. (Courtesy of Peter Marsh.)

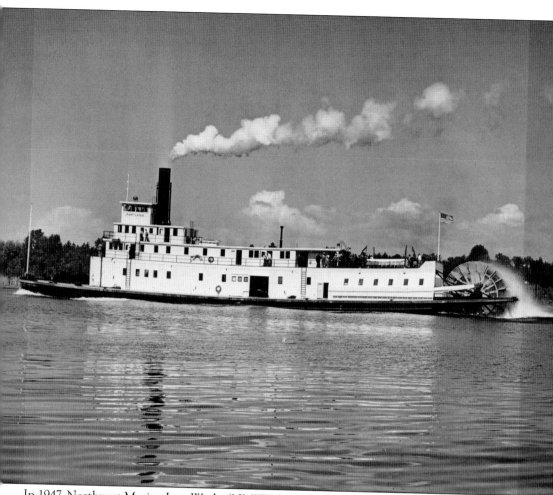

In 1947, Northwest Marine Iron Works (NMIW) built the *Portland*, designed by Guy H. Thayer, for the Port of Portland Commission. When the towboat *Portland* began to wear down, it was assumed that a modern tunnel-stern, multiple-screw diesel vessel would replace her. Portland Harbor pilots, however, insisted that a powerful sternwheel steamboat of conventional design was needed to work within the narrow confines of the Willamette River. After considerable controversy, the pilots won, and the new *Portland* was built. She was 219 feet in overall length with a 42-foot beam, 9-foot hold, 5.5-foot draft, and two 900-horsepower steam engines; she had steel-hull-supported wood upper decks, as well as a cabin deck, Texas deck, and wheelhouse. Two river tugboat companies—Western Transportation and Shaver Transportation—operated the *Portland*. She served her working life as a Portland Harbor tug until she was decommissioned in 1981. In 1989, she was completely restored by the Oregon Maritime Museum. Still fully operational, she continues to serve the Portland waterfront and periodically steams up. (Courtesy of Peter Marsh.)

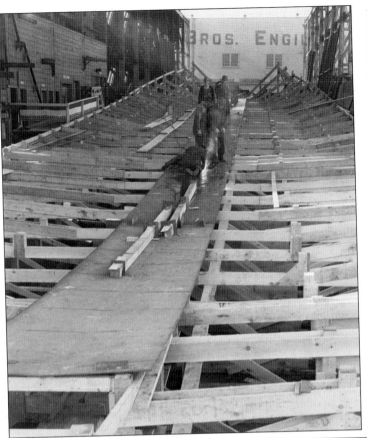

By the time the new *Portland* was ready to go to work, much of the maritime businesses along Portland's waterfront had a share in her. The keel of the sternwheeler was laid on February 3, 1947, in the Gunderson Brothers Engineering Corporation's dry dock, an area leased by the NMIW. She was launched on May 24, 1947, and her predecessor, the old *Portland*, was scheduled for retirement as soon as the new *Portland* was commissioned for service. One of the last jobs for the old *Portland* was to tow the new *Portland* to the Port of Portland's dry docks for completion. (Both courtesy of Peter Marsh.)

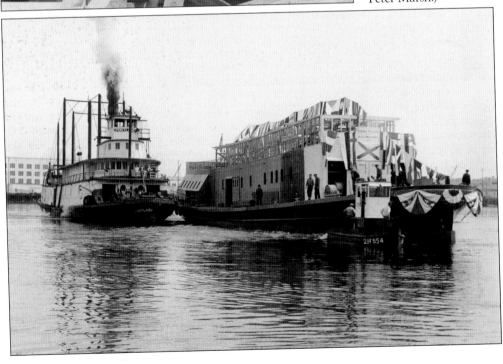

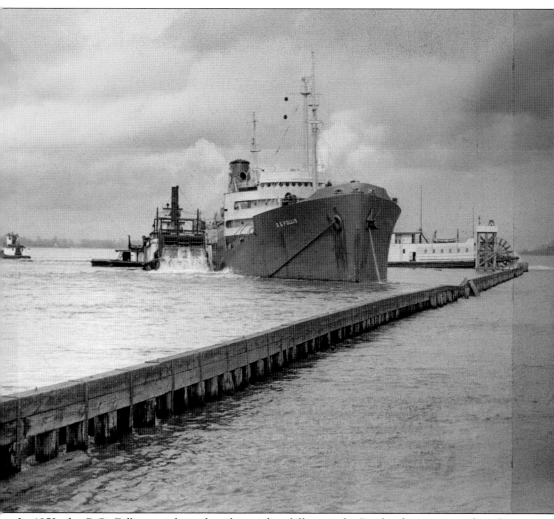

In 1952, the *R.G. Follis*, an inbound tanker with a full cargo for Portland, ran aground in the Columbia River near the mouth of the Willamette. The tanker lost her steering, and by the time she stopped, her bow had been deeply entrenched in the sandy bottom at the Sauvie Island dike (approximately 10 miles northwest of downtown Portland). Several tugs were called to her aid, but to no avail. The ship-assist sternwheeler *Portland* arrived on the scene, attaching lines to the stranded ship and getting to work. With the *Portland*'s powerful engines in reverse, the wash from her paddle wheel began to loosen the sand under the tanker. Her rudders were able to work the tanker from side to side until the suction underneath was broken and the ship moved backward, free from the riverbed. Once the *R.G. Follis* was afloat, the *Portland* helped by towing her into the Portland Harbor to her own dock. (Courtesy of Peter Marsh.)

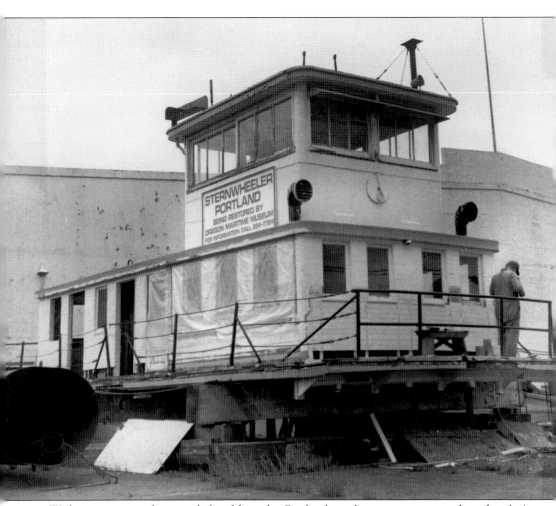

With many years of service behind her, the *Portland* was becoming worn and outdated. Any hopes of keeping her as a working assist tug were no longer practicable. The last restoration plan was believed to come from the Port of Portland to prepare the sternwheeler for a new purpose. This arrangement involved removing her wheelhouse and Texas deck in one piece and setting it on the beach. The wooden deckhouse that was the crew's quarters was not salvageable; the deckhouse had too much dry rot and was in poor condition. This left the *Portland* with only her steel engine and boiler room still on the hull. It was a sorry sight. The port had planned to make her a cruise boat, but in the end, it was too costly, and the *Portland* deteriorated at Terminal No. 1 for many years. In 1991, the Port of Portland gave the Oregon Maritime Museum the funds to begin a full restoration of the *Portland* sternwheeler, one of the last operating steam sternwheelers in America. (Courtesy of Peter Marsh.)

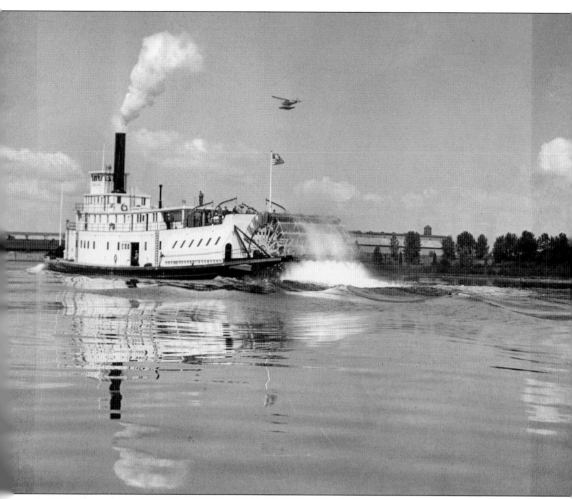

In 1991, the sad remains of the once proud *Portland* were deeded to the Oregon Maritime Museum. Volunteers repaired, painted, and restored her from bow to stern. In 1993, just as the boat was back in running condition, a Hollywood studio that had heard about the *Portland* restoration hired her for the movie *Maverick*, starring James Garner, Mel Gibson, and Jodi Foster. The *Portland* was to play the role of a Mississippi-style gambling boat, the *Lauren Belle*. Since she had taken only a couple of short "shakedown" cruises, the museum did not want the boat to run anymore before the actual shooting of the film, set on the Columbia River in Dodson, Oregon, about four and a half miles east of Multnomah Falls in the Columbia Gorge. During filming, the *Portland* was gussied up with two dummy smoke-emitting stacks and plenty of gingerbread ornamentation. She worked flawlessly during the many exciting and difficult tasks asked of her from the film crew. To this day, the *Portland* is berthed on the Willamette River as a home for the Oregon Maritime Museum. (Courtesy of Peter Marsh.)

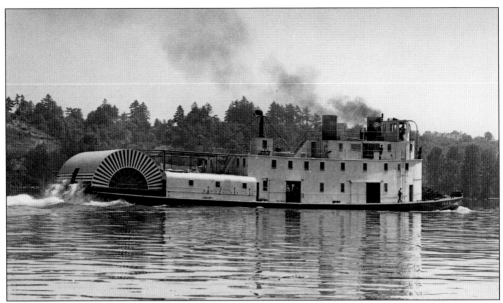

The *Jean* is the last semi-intact sternwheeler to operate on the Willamette and the only one with split paddle wheels. The wooden paddle wheels are about 20 feet in diameter from side to side, 16 feet wide at the axle, and roughly 10 tons each. Commercial Iron Works built the *Jean* in Portland in 1938 for the Western Transportation Co., a subsidiary of Crown Zellerbach Corp. Designed to tow logs and handle barges, she was 140 feet long and 533 gross tons. In 1957, she was stripped of her machinery and equipment and left to rot. The boat was last docked at the Port of Wilma, Washington, before making the journey—lashed to a grain barge and pushed by a tugboat—to Portland, where she would work as a response vessel. (Both courtesy of Peter Marsh.)

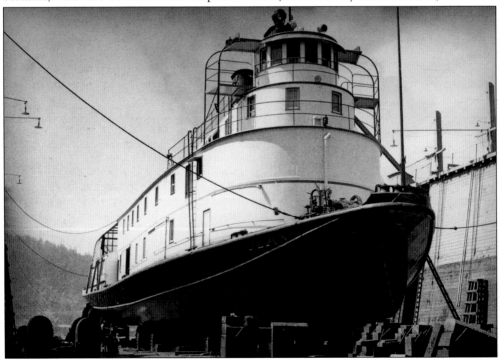

Two

COMMERCIAL SHIPPING

Early in its history, Portland's viability was based on its location at the Willamette River's confluence with the Columbia River, accessibility for deep-draft ships, and gate to the Pacific Ocean. Portland became the easiest and most logical place for oceangoing transport of cargo with upstream shipping and then loading goods onto railroads and trucks. The result of this twofold layout made Portland a city for both the land and the water. Portland is one of the last cities in the United States that was started and industrialized as an ocean-to-river port first and rail center second (others include Houston and Sacramento).

Portland became the supply core for area farming communities and a regional shipping center. The deep, freshwater harbor helped grow the city into a vital part of the developing lumber industry, and moving lumber became more efficient because of the simplicity of transportation.

Established in 1860, the Oregon Steam Navigation Company was the first steamship company in Portland, expanding all cargo transportation in Portland by building a vital shipping port. The creation of this company helped make Portland today the third-largest port for outgoing cargo on the West Coast, with import and export shipments of over $11.8 billion.

The Portland Harbor has the biggest wheat export in the United States and the third largest in the world. The Port of Portland is also the third-largest auto import gateway in the country. Freight along the Columbia River in Portland also draws cargo from east of the Mississippi, making the Port of Portland the nation's second-largest corn export center. Portland is even the most important bulk mineral port on the West Coast. As it was when it began over a hundred years ago, Portland is now one of the largest export tonnage port hubs in the United States, thanks to the ships that come and go on her rivers.

At the beginning of both the 19th and 20th centuries, Portland was the largest city in the Pacific Northwest. Her profitable location near the union of the Willamette and Columbia Rivers gave suppliers access to both inland agriculture areas and foreign markets. Steamboats and railroads transported farm products and natural resources from Idaho, Washington, and Oregon to Portland. From there, they were loaded onto ships for marketplaces in the eastern United States, Asia, and Europe. Portland also served as the entry point for incoming trade goods to the area. In 1891, the state legislature established the Port of Portland Commission for the chief purpose of dredging a Columbia River shipping channel from a depth of 17 to 25 feet. In the following years, the port continued to deepen the channel to accommodate larger ships. In the 1920s, the port moved the main Willamette River shipping channel from the east to the west side of Swan Island. (Courtesy of Peter Marsh.)

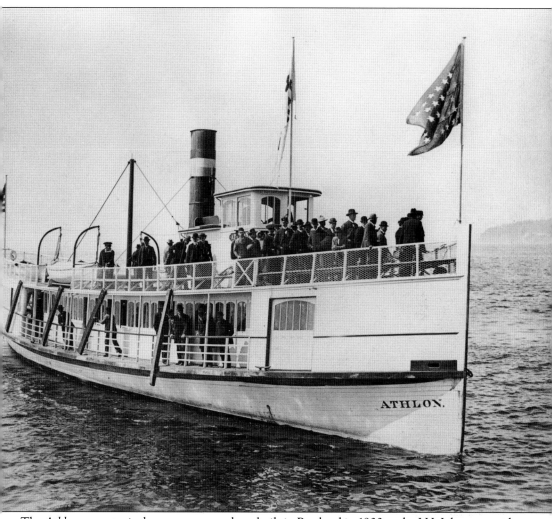

The *Athlon* was a typical passenger steamboat built in Portland in 1900 at the J.H. Johnston yard. She was 112 feet in length with a 19.7-foot beam, 7-foot draft, and 157 gross tons. Her first owners were Jacob Kamm (and his Vancouver Transportation Company), the Shaver Transportation Company, and the Kellogg Transportation Company. In 1907, *Athlon*'s compound engine was replaced with a triple-expansion steam engine. About the same time, she was converted to oil fuel in response to the oil companies launching a push to sway the steamboat operators to convert from burning cordwood or coal to burning oil. The *Athlon* was sold to H.B. Kennedy, who took her up to Puget Sound. On August 1, 1921, in a heavy fog, the *Athlon* struck the Ludlow Rocks at the harbor entrance. She crashed at extreme high tide, and at low tide, it was possible to walk around her. The nine people aboard all reached safety, but she was a total loss. Her owner, Poulsbo Transportation Co., was able to salvage her machinery. (Courtesy of Shaver Transportation.)

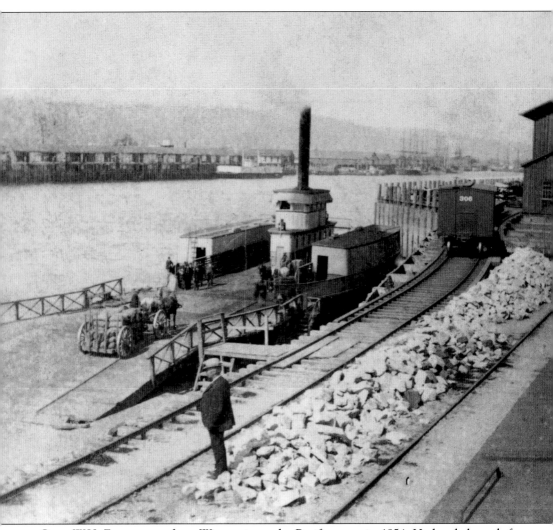

Capt. W.H. Foster came from Wisconsin to the Pacific coast in 1854. He headed north from San Francisco in 1872 to the young town of Portland, where he ran the Stark Street Ferry for a few years, then bought the *Salem No. 2* ferryboat and used her on the Vancouver ferry route. After buying and selling a few more boats, in 1883, Captain Foster took the ferry *Albina No. 2* and reconstructed her for use on the Portland run. She had been originally built that same year in Portland, so she did not require too much alteration. She was 205 gross tons and 107 feet in length, with a depth of 32.5 feet. She is shown here loading cargo on the Willamette River in 1885. Horse-drawn carts and buggies were still the standard of the time. Portland remained her home port. (Courtesy of Oregon Maritime Museum.)

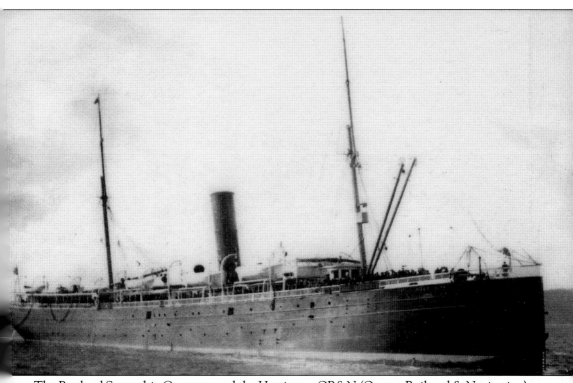

The Portland Steamship Company and the Harriman–OR&N (Oregon Railroad & Navigation) Co. bought the former Army transport *Lawton* in 1908. They had her rebuilt to the finest standards of the time, adding a wireless telegraph and electric lights, and renamed her the *Rose City*. Though she looked like a brand-new ship, she was actually built in Chester, Pennsylvania, in 1889 as the *Yumari*. Later called the *Badger*, she was used as a naval auxiliary ship before becoming the *Lawton*. She was a steel steamer with three decks and two masts, at 3,468 tons, 336 feet in length, and a 43.2-foot beam. She had a crew of 68, capacity for 389 passengers, and speed of 15 knots. Propelled by a single prop driven by a triple-expansion steam engine, she operated at 200 pounds of pressure supplied by four boilers that produced 1,750 horsepower. Once her work was finished in Portland, she was later sold and used as the gambling ship *Rose Isle* off the California coast, then sold to salvagers in 1935. (Courtesy of Oregon Maritime Museum.)

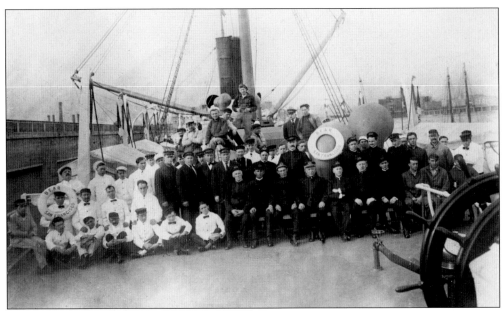

The Newport News Shipbuilding and Dry Dock Company in Virginia built a steel steamer in 1910 called the *Bear* for the San Francisco and Portland Steamship Company. Her ports of call were Portland, Astoria, San Francisco, and San Pedro. The steamer was one of the largest and most modern passenger-carrying crafts on the Pacific Ocean. She had three decks, two masts, and a 79-person crew, and could carry up to 4,507 tons, including 545 passengers. The *Bear* was 380 feet long, and she burned coal or oil as fuel. The ship was built in conjunction with the Southern Pacific Railroad Company, which owned and operated the San Francisco and Portland Line. When the *Bear* sank on a foggy night two miles north of Cape Mendocino, California, on June 14, 1916, there were very few survivors. (Both courtesy of Peter Marsh.)

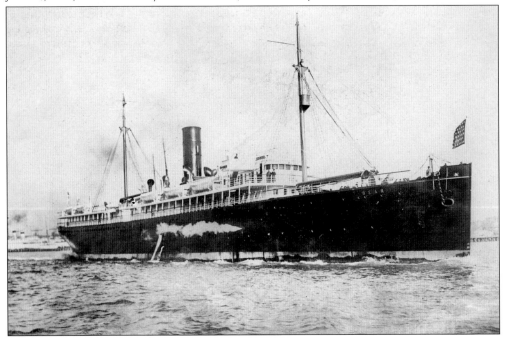

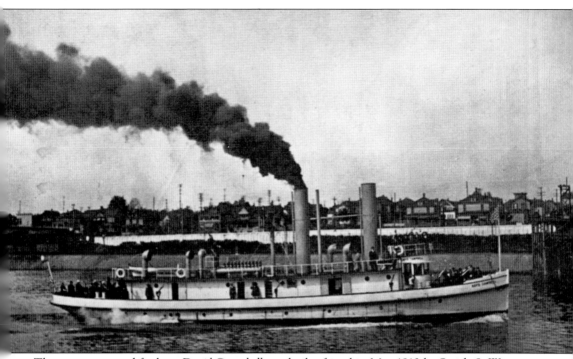

The steam-powered fireboat *David Campbell* was built of steel in May 1913 by Smith & Watson Iron Works in Portland. The *David Campbell* was the first of three new $100,000 fireboats for the city. (The other two were the *Karl Gunster* and the *Mike Laudenklos*.) The *Campbell* weighed 242 gross tons and measured 125 feet long with a 25.5-foot beam and a draft of 8 feet and 7 inches. She had two specially designed Ballin water-tube boilers, each 1,400 horsepower, and two Sterling Viking II motors rated at 565 horsepower at 1,200 rpm. The crew consisted of 21 men, including a master, pilot, three engineers, three stokers, a captain, two lieutenants, and 10 hosemen. Generally, 10 men worked on duty by day and 15 at night. The *Campbell* was designed by A.D. Merrill, working in collaboration with fire chief J.G. Holden. She stayed on duty until 1928, when a new gasoline-powered boat replaced her. (Courtesy of Peter Marsh.)

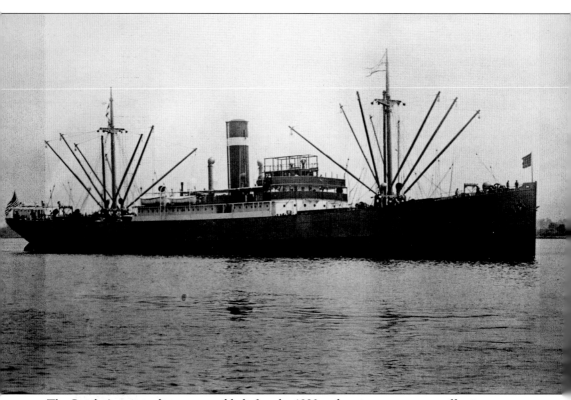

The South American liners were added after the 1920s, when it was more cost effective to operate through the Panama Canal than running freighters through Cuban waters. One of the new steamer lines put into operation then was W.R. Grace & Company of New York. The services to the northwest coast were carried out by the Atlantic & Pacific Steamship Company, which provided a fortnight package from the port of call. W.R. Grace & Company, which had a branch in Portland, oversaw the operations of the liners *Santa Clara*, *Santa Catalina*, *Santa Cecilia*, and *Santa Cruz*. These were new, dynamic 10,000-ton American steamers, used specifically for the canal trade ports in Colombia, Ecuador, Peru, and Chile. Branches for the sale of American products and the deposits of freight were maintained by W.R. Grace & Company in all principal cities on the West Coast, including Portland. (Courtesy of Peter Marsh.)

A German bark, the *Lisbeth*, berthed at the Portland docks, awaits the remains of her lumber cargo of about 2.2 million board feet. She stowed her final freight at the plant of the Eastern & Western Mill in Portland. It was July 11, 1926, and in three days, the *Lisbeth* left under tow for Astoria. She had arrived on May 18 on her second trip to the Columbia River, the first having been on December 10, 1912. On her first call, she was 45 days from Callao, Peru, the port to which she was bound with her cargo. Captain Windhorst had been to Portland before, and on this trip, he renewed his past relationships. In earlier times, the view along the beach was filled with square-rigged vessels instead of the powered carriers that prevailed in 1926. For the crew of the *Lisbeth*, there were many attractions in Portland; the captain had to keep his men on time when reporting back to duty. (Courtesy of Peter Marsh.)

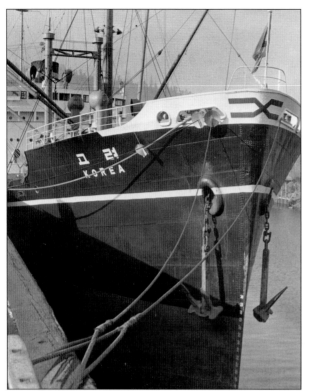

The MS *Korea*, owned by the Far Eastern Marine Transport Co. Ltd. in Seoul, Korea, completed her first round-trip voyage ever made while flying the Korean flag. In 1952, she made her historic arrival in Portland and was welcomed by the city commissioners and the community. According to the Japanese records, there were 215 merchant ships destroyed during the Asia-Pacific War. This vessel, along with many others, was salvaged from Korean waters. After their independence in 1945, the Koreans salvaged everything possible from these sunken crafts. They were only able to refloat three—the MS *Korea*, the MS *Hanyang*, and the MS *Seoul*—which were restored and able to transport freight by the spring of 1951. The number of Korean oceangoing ships gradually increased year by year. (Both courtesy of Peter Marsh.)

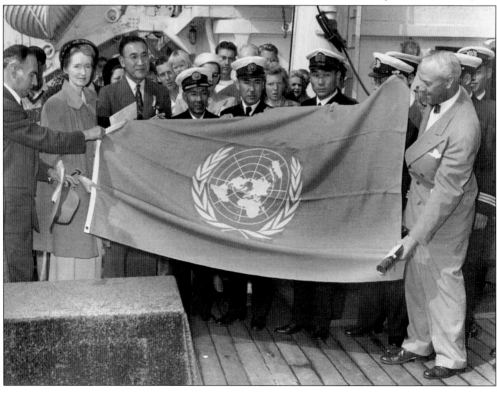

Portland is home to the oldest tug and barge operations in the Pacific Northwest. The Portland Barge & Tug Co., a forerunner in maritime commerce, was one of these companies located on the Willamette River. A tugboat (tug) manipulates crafts by pushing or towing them. Tugs move vessels that cannot safely berth in a busy harbor or those that cannot move alone, such as barges, immobilized ships, log rafts, or oil platforms. Tugboats are sturdy for their size and strongly built; some are even oceangoing. Tugboats have assisted in ice breaking, firefighting monitors, and salvage work. While the early tugs had steam engines, most today have diesel engines. (Both courtesy of Peter Marsh.)

The Columbia Slough is a narrow waterway, about 19 miles long, in the floodplain of the Columbia River. Starting in Fairview, a suburb of Portland, the slough twists west toward the Willamette River's confluence with the Columbia. Tugs worked commercial log rafting along the Columbia from the 1930s, supplying the Kenton Shingle Company, the Columbia Shingle Company, and the Kenwood Lumber Company, all located in Portland on the Lower Slough, along with nine other prominent wood companies. The Columbia Shingle Company used 75,000 board feet of lumber per day, and Kenton Lumber Company used 500,000 board feet of lumber per month for shingles and boards. Above, the tugboat *Lyle H.* pushes logs to a shingle mill boom (below) just west of North Denver Avenue. (Both courtesy of Peter Marsh.)

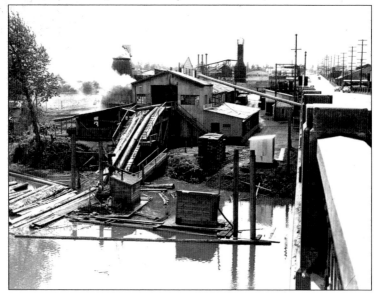

The Douglas fir, also known as the Oregon pine or red fir, to distinguish it from the true fir of California, is perhaps the most common tree in Oregon. In earlier times, Native Americans used Douglas fir wood for fuel, hand tools, and utensils. They used its pitch for fastening joints and for waterproofing canoes and containers. They also used certain parts of the tree for medicinal purposes. It is the most important conifer in the state because of its ecological and economic value. The Oregon legislature recognized this when it designated the Douglas fir as the official state tree in 1936. When more people settled along the rivers in Portland, they quickly established the Douglas fir as their primary source of timber. Soon, lumber mills sprang up and sold large timber beams, manufacturing boards, railroad ties, plywood veneer, and wood fiber for paper companies. This wood sold not only in Portland but was exported all around the world. Even today, countries like Japan import the Douglas fir from the northwest, shipping it right from Portland. (Courtesy of Peter Marsh.)

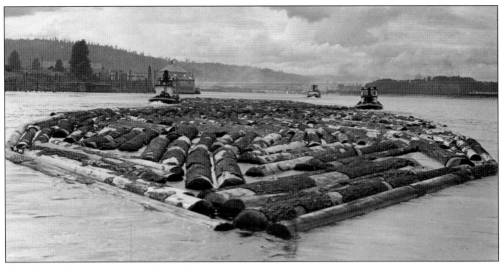

As early as the 1780s, Capt. John Meares identified the quality of northwest timber for use as ship masts and spars. Soon after, Oregon was viewed as an almost unlimited supply of trees from its lush forests. Once the railroad arrived in Portland in 1883, the lumber industry burst onto the market. By 1827, the first sawmill was built in the Pacific Northwest. In 1833, the first shipment of Oregon timber was sent to China. Many entrepreneurs made a fortune by providing timber and fruit to the California miners during the Gold Rush days. During World War II, the shipbuilding surge began in Portland. Oregon law requires reforestation after timber harvest. Even today, lumber has played an important role in the development of Portland as a key city along the Columbia River. (Above, courtesy of Shaver Transportation; below, courtesy of Peter Marsh.)

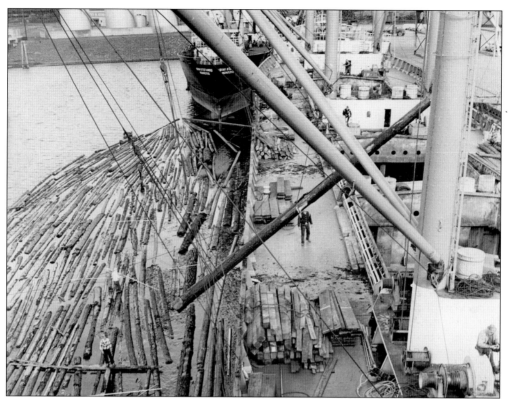

Lumber schooners heading for California loaded into the Portland Harbor. Portland was the number one lumber shipping and manufacturing center in the world, according to *Harper's Weekly* of May 24, 1913, and it remained the leading transporter of lumber and wood products into the mid-1920s. Usually, the vessels used for lumber were the only connectors between the timber ports and their final destination. They brought all types of supplies to the docks and returned with lumber, farm produce, and even livestock. Most of the hulls were built on the Pacific coast, then towed to San Francisco and loaded with cargo for completion. (Both courtesy of Peter Marsh.)

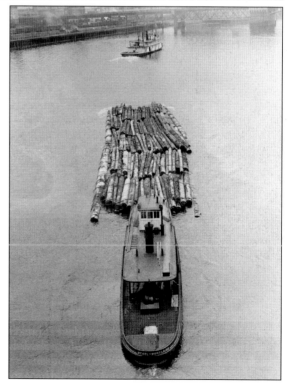

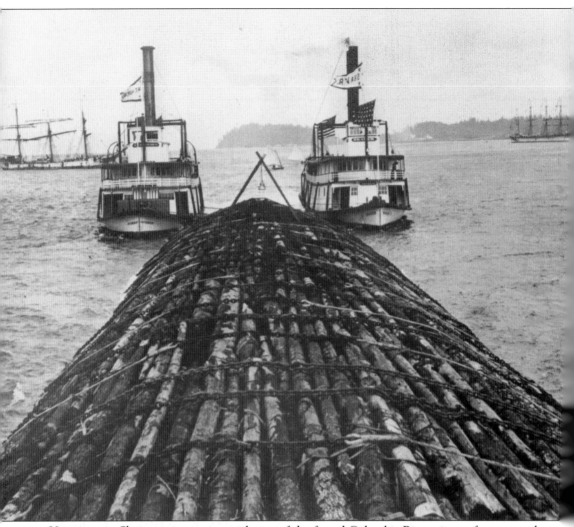

Here are two Shaver tugs assisting with one of the famed Columbia River cigar rafts—upwards of six million board feet of logs strapped into a bulky form by chains normally used for a ship's anchor. Just like an iceberg, these logs floated while drawing 20 feet of water with just 7 feet of freeboard. These logs were heavy and cumbersome to tow, but this was the most economical way of transferring such large amounts of valuable timber to the eager markets. As early as 1894, there had been many attempts to create these cigar rafts to flow securely along the Columbia River to the Pacific Ocean. Simon Benson (originally Bergerson), a Norwegian immigrant, finally developed a system that worked. To build his rafts, Benson created the Benson Lumber Company, which stayed in business until 1923. (Courtesy of Shaver Transportation.)

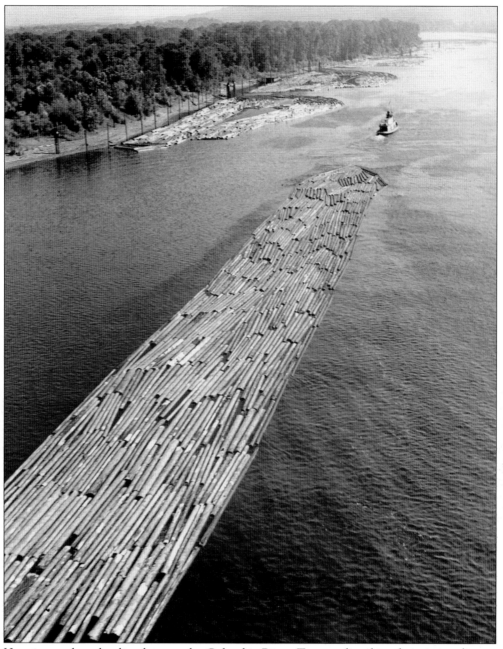

Here is a tugboat hauling logs on the Columbia River. Tugs are listed in classes according to "bollard pull," as certified by the American Bureau of Shipping (ABS) or another acceptable independent authority. Bollard pull is used instead of horsepower because it is the only significant way to rate a tug's efficiency. Also, the tug's design type, such as a tractor, twin screw, or single screw, as well as the addition of Kort nozzles and flanking rudders, has an exact outcome on the utility and efficiency of a specific tug. The assigned pilot or operations pilot must preapprove the use of any vessel that has not been certified. On smaller waterways, logs simply could be dumped into the water to drift downstream. Portland's waters have long been far too busy for such casual portage. (Courtesy of Peter Marsh.)

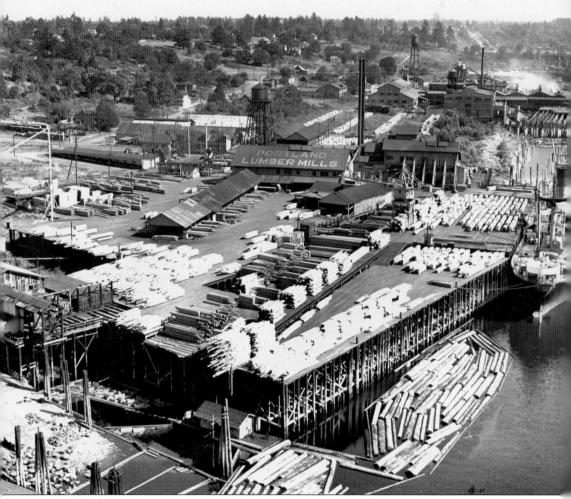

Tons of lumber, rolling logs, and needed cargo are stacked up all along the Portland docks during the worst maritime strike in history, which stopped all shipping in American seaports. The AFL and CIO unions set a wage strike for maritime workers that began on September 5, 1946, and ended in Portland when the last pickets left their waterfront posts on Sunday, September 22. The storage yard at the Portland Lumber Mill beneath the St. Johns Bridge was blocked with unfastened pilings that Sunday while the SS *Rice Victory* waited alongside. Loading began on the following Monday, September 23. In the foreground sits the Skookum Company Inc., which created comprehensive block, fairlead, sheave, hook, and alloy forging. Still in business today, but now located in Hubbard, Oregon, Skookum serves the logging, maritime, mining, commercial fishing, petroleum, military, and offshore industries. (Courtesy of Peter Marsh.)

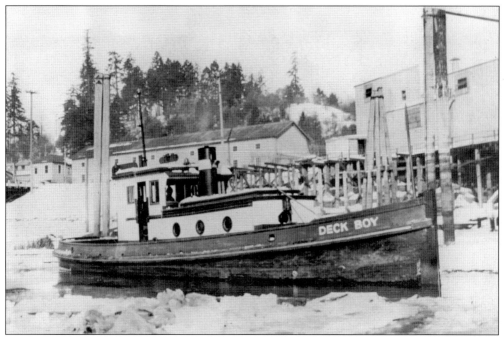

The Shaver Transportation Company merged five of the larger transportation companies under its name: Smith Transportation, Knappton, Hosford Transportation, Willamette & Columbia River, and Callender. Shaver acquired the *Logger*, the *Wilavis*, the *Smithy*, the *Nora*, the *Deck Boy*, and the *Service* (formerly the *Inland Empire*), which was later dismantled. The *Smithy*, renamed the *Klickitat*, and the *Wilavis*, renamed *Cowlitz*, stayed in the Shaver fleet until they were dismantled. (Courtesy of Shaver Transportation.)

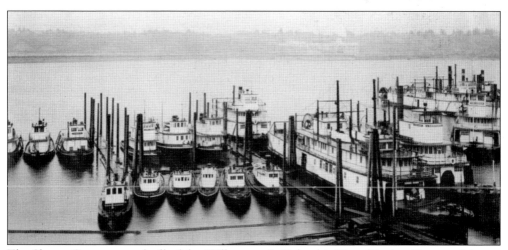

The Shaver Company took all of the Willamette & Columbia River Towing Company's boats, including the *Skookum*, the *Gamecock*, the *Umatilla*, and the *George W. Simons*. They also acquired the *Treve E.*, a very sturdy little towboat. A replacement for the original tug, the *Umatilla*, a steel twin-screw diesel built in 1978, is still working in the Shaver fleet. (Courtesy of Shaver Transportation.)

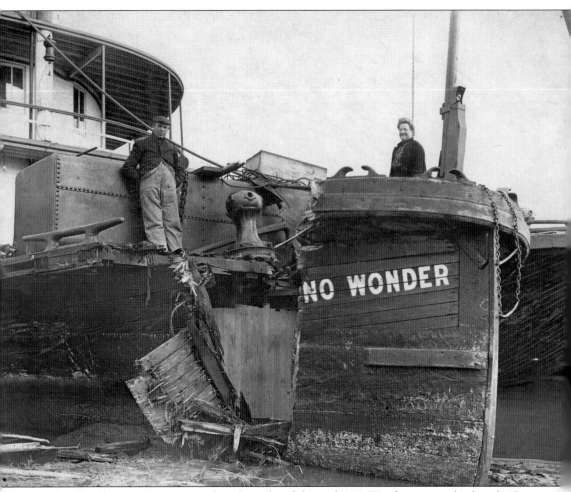

In 1897, Shaver Transportation bought its fourth boat, the *No Wonder*, a sternwheeler of 235 gross tons built by George Washington Weidler of Weidler Mills. Weidler cut and seasoned the timber planned for his boat for two years before building it in 1877. He named her *The Wonder*. He later rebuilt the towboat in 1889. Her abilities were beyond what could be expected from a boat of her size, and fellow workers often would say, "no wonder," in referring to it, so he changed her name to the *No Wonder*. Shaver Transportation used the *No Wonder* for towing logs and as a training school for pilots until 1933, when she broke apart and was then dismantled. Since wooden-hulled boats break down quickly in comparison to steel-hulled boats, 56 years of use was an exceptional length of time for her to be working on the rivers. (Courtesy of Shaver Transportation.)

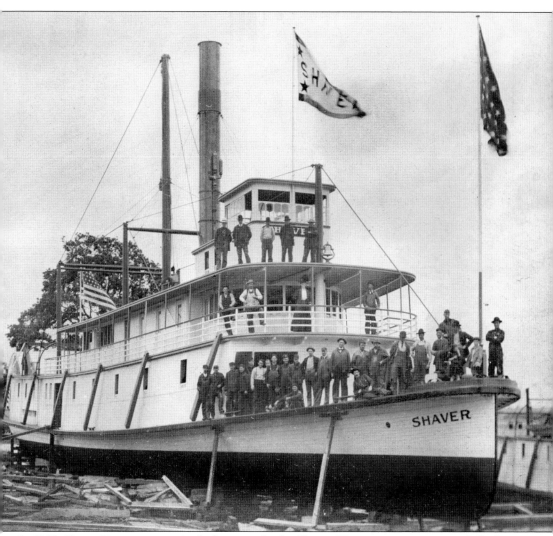

In 1908, Shaver Transportation built the sternwheeler *Shaver*. The company constructed all of its steamboats as sternwheelers, which gave them a great advantage on the rivers. Sternwheelers do not require fixed docks for landings, and are more powerful and easier to steer than the traditional sidewheelers. During that time, most steamboats on the Columbia River system were sternwheelers. In 1926, Shaver Transportation broke away from this design by rebuilding the *Shaver* as a twin-screw diesel boat. The *Shaver* served in this configuration for about 20 years. The *Shaver*'s hull and engine included previously used mechanical components from other steamboats; this was a common practice in building and repairing steamboats. In the *Shaver*'s case, these included steam valves that had served in at least two previous vessels going back to 1857. Once built, the *Shaver* was used as a tow and workboat. The same design for the rebuilt *Shaver* was later used by Marietta Iron Works to build a vessel that became the pattern for future towboats on the Ohio and Mississippi Rivers. (Courtesy of Shaver Transportation.)

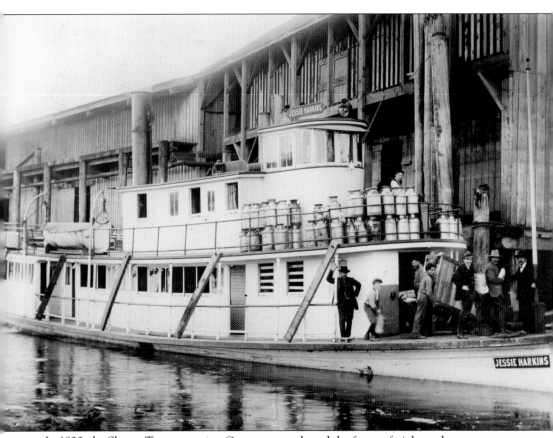

In 1920, the Shaver Transportation Company purchased the former freight and passenger steamer *Jessie Harkins* from the Harkins Transportation Company. Lovelace Perne Hosford, Henry L. Pittock, and A.J. Lewthwaite founded Harkins in 1914; the company was named after their steamer, which had been named after L.P. Hosford's niece. The *Jessie Harkins* was built by Jacob Kamm, a renowned and successful builder in Portland. The 150-horsepower propeller passenger steamer was 88 gross tons and 88 feet in length. She was placed in service between Portland, Camas, and Washougal by the Harkins Transportation Company, which ran steamboats on the lower Columbia from 1914 to 1937, until it went bankrupt. Once the Shaver Company had the *Jessie Harkins*, it removed her deckhouse and outfitted her as a towboat, renaming her the *Pearl*, after Pearl Hoyt, the sister of Capt. George W. Shaver. In 1925, it was converted into a 200-horsepower diesel screw propeller. The *Pearl* worked until 1957. (Courtesy of Shaver Transportation.)

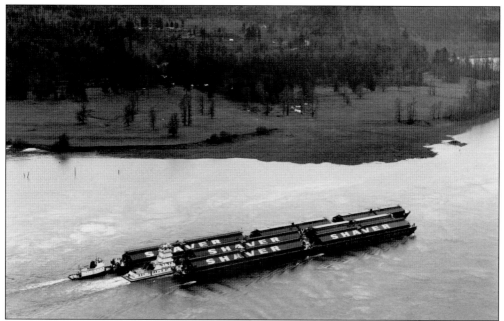

In 1880, George Washington Shaver helped create the People's Freighting Company. In 1893, George W. Shaver and his sons James W. Shaver and George M. Shaver incorporated the Shaver Transportation Company. By 1914, their fleet comprised seven tugs. By 1920, they had two dozen steel-hulled diesel tugs, as log towing was now their main venture. They established themselves in ship-assist work in Portland and in ocean towing from Alaska to the Panama Canal. Currently, the company includes Harry L. Shaver as chairman of the board, son Steve Shaver as president, and daughter Samantha Shaver as a member of the board. In 1981, they designed and built the first Z-drive tractor tug on the West Coast, called the *Portland*. They operate the largest and most modern fleet of ship-assist tugs on the Columbia River. (Both courtesy of Shaver Transportation.)

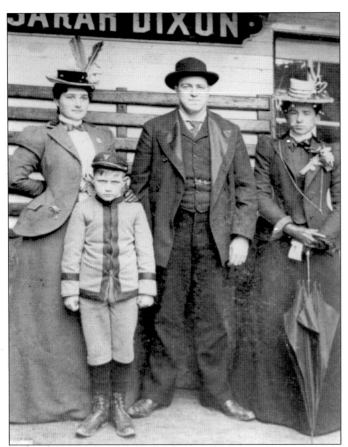

As the new century was just settling in, Portland on the Willamette River was becoming a busy and lively place for steamboats. Here in 1906 stands the Shaver family in front of the wooden sternwheeler *Sarah Dixon*. Pictured are, from left to right, Sarah Shaver, George M. Shaver, Homer T. Shaver, and Nellie Monical. (Left, courtesy of Oregon Maritime Museum.)

The steamer *Governor Newell* is shown here with another steamer and a dredge in tow on the Willamette River near the 8th Street dock in Oregon City. The *Governor Newell* was built in Portland in 1883. She was 206 gross tons and 112 feet long. She was dismantled in 1900. (Below, courtesy of Oregon Maritime Museum.)

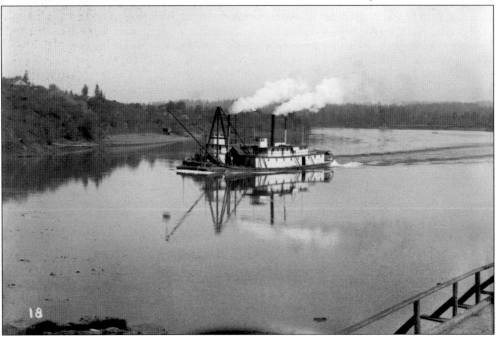

The *Portland* was a 289-foot-long freighter that was initially called the *Jacox*. In 1942, the *Portland* worked along the Pacific coast before she was moved to the Atlantic Ocean in January 1943. There, her first job took her from Philadelphia to Havana. On February 11, 1943, she was trapped in a storm and ran aground in the shallow waters of Cape Lookout. All of the crew abandoned ship before the seas hammered and sunk the ship. To this day, she is still resting in 55 feet of water, stuck in the seabed. Interested scuba divers can find her about 18 miles southwest of Beaufort Inlet in North Carolina. Incidentally, while still named the *Jacox*, she was involved in a collision with a passenger ferry while coming into harbor at Seattle on March 2, 1934. Both ships survived with very little damage and continued on their way. (Courtesy of Peter Marsh.)

The derrick barge *Cairo* is shown here being assessed for her lifting durability. To test the strength of her recently extended 140-foot steel boom, she was given 221.5 tons of concrete blocks to lift. After successfully proving her capabilities, she was ready for her next job. With two diesel tugs riding on her forward deck, this giant derrick barge departed on May 20, 1949, in the tow of the *El Sol*, for Morgan City, Louisiana. Once there, she would work for Portland Tug & Barge Company, assisting in the construction of oil-drilling platforms. The Portland tugs *Hulda* and *Superior* were sent along for support. (Both courtesy of Peter Marsh.)

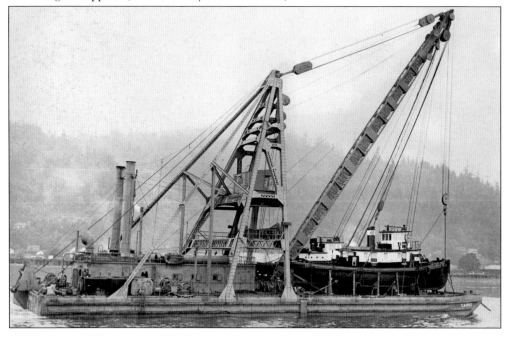

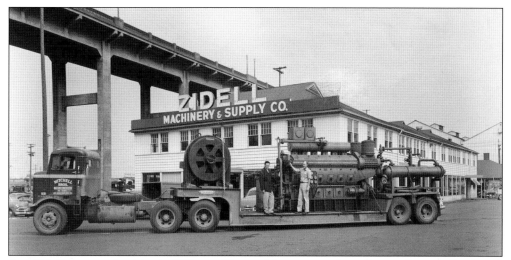

Sam Zidell came to America in 1912 as a 17-year-old immigrant from Eastern Europe. Sponsored by his uncle to travel to Portland, he quickly learned the language and customs of his new homeland. By 1917, he opened a company on Portland's waterfront selling mill, logging, and plumbing supplies. By 1940, the store had grown to become the Zidell Machinery & Supply Co. After World War II, business grew for Zidell when the company began dismantling ships on the site of the former Commercial Iron Works shipyard, just south of the Ross Island Bridge. Soon thereafter, Zidell became one of the largest ship-breakers in the United States. (Both courtesy of Zidell Marine.)

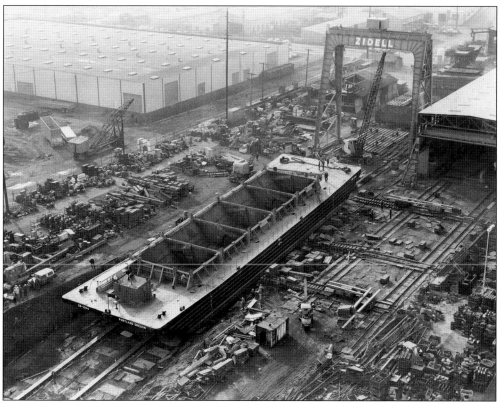

In 1946, Sam Zidell's son Emery became a partner in his father's business after he was discharged from the Navy's Sea Bees. Emery took the trade into a joint partnership with Oregon Steel Mills from 1946 to 1948 and formed Zidell Ship Dismantling Co. They bought and dismantled many ships in Portland. As his partners elected to sell out, Zidell kept his company at the site of the old Commercial Ironworks Shipyard, under the name of Zidell Machinery & Supply Co. From this work, Zidell developed businesses that continued to be their focus: barge construction and leasing, manufacturing and selling welding fittings (which are the tees and elbows used in pipelines for their company, Tube Forgings of America Inc.). Over a span of 30 years, Zidell dismantled 336 ships, including many World War II Liberty ships, naval auxiliaries, and warships. As the company grew, Zidell kept his leadership active by managing the family business and leading it through its most productive growth and development from 1950 to 1980. (Courtesy of Zidell Marine.)

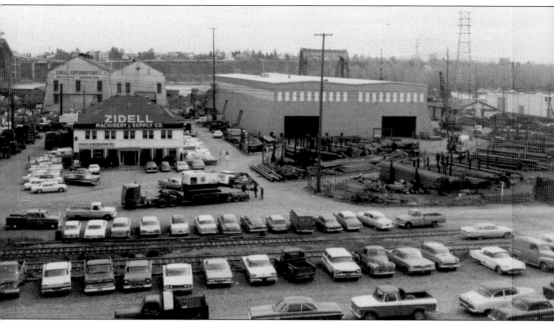

For more than 67 years, the Zidell family has kept their companies active in Portland. Jay Zidell, who grew up in the business built by both his father and grandfather, transitioned into the leadership role in the 1990s. Located in the heart of Portland's South Waterfront District, the Zidell family's 33-acre shipyard is along the Willamette River. Currently, Jay has led the effort of redeveloping the site, which includes nearly 3,000 linear feet of waterfront. Matthew French—Jay's nephew, Emery's grandson, and Sam's great-grandson—manages the real estate activities for Zidell and is the fourth generation of this family to be active in the business. While Zidell Marine is still headquartered in Portland, their barges can be seen all around the West Coast, Alaska, Hawaii, and in ports of the Columbia and Snake Rivers system. Neighboring businesses and residents still stop to enjoy the launch of each new Zidell vessel. (Courtesy of Zidell Marine.)

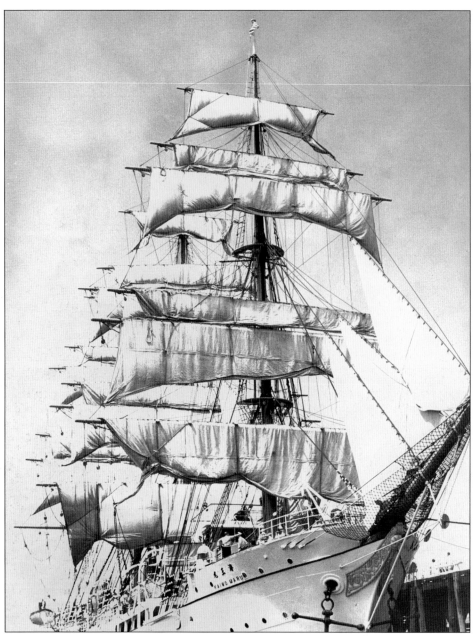

The *Kaiwo Maru* (loosely translated as "King of the Sea" or "Neptune Ship") is a fully rigged, four-mast barque that was launched on February 14, 1930. Her steel hull was about 328 feet long with a displacement of around 2,300 tons. The *Kaiwo Maru* was a sailing training ship built by the Kawasaki Shipyard (Kobe, Japan) for the Imperial Japanese Navy. She served during World War II as an auxiliary naval transport when her sails were detached and she cruised under diesel power alone. After the war, she was again used as a training ship. She was decommissioned in the 1980s but kept as a museum ship. Her role as a training vessel was taken over by a new and nearly identical *Kaiwo Maru* built in 1989. Ships like the *Kaiwo Maru* often paid visits to the seawall between the Morrison and Burnside Bridges in the late 1950s and 1960s, as Harbor Drive had not yet been removed to make way for Tom McCall Waterfront Park. (Courtesy of Peter Marsh.)

The ship's anchor chain must support a heavy piece of metal. The anchor's fork shape and size differ depending on the size and type of ship. The chain, usually no more than 300 feet, is made from heavy metal links and holds the anchor at one end, while the other end is secured to the vessel. (Right, courtesy of Peter Marsh.)

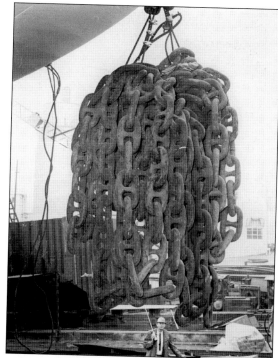

The main engine of a ship is roughly amidships. Braced by numerous supports, the long shaft runs through an alley in the stern of the vessel, where it connects the engine with the propeller via a thrust bearing. The engineers are always on call in an effort to keep the work efficient and accurate. (Below, courtesy of Peter Marsh.)

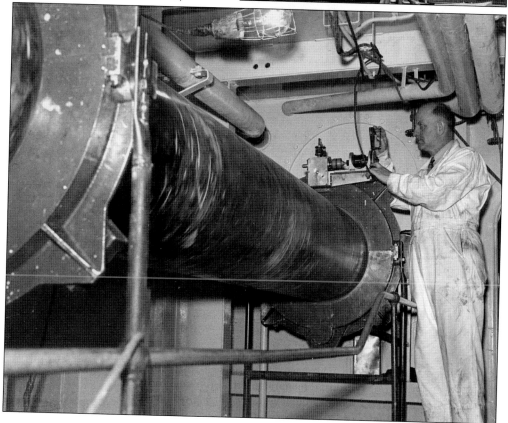

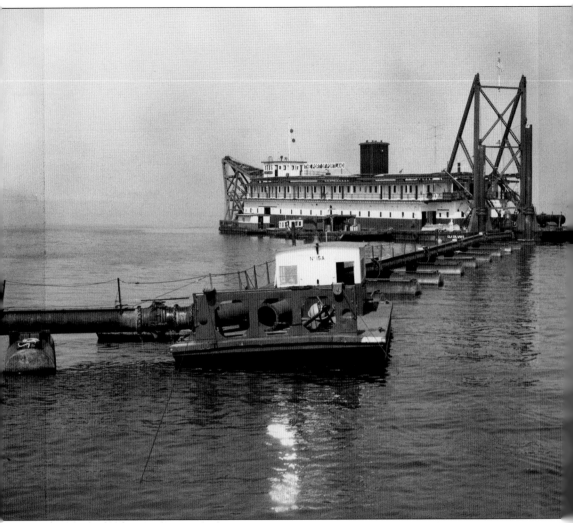

Efforts to maintain and improve the navigation channels have continued even today. In 1989, Portland and five other ports (Vancouver, St. Helens, Woodland, Kalama, and Longview) asked the US Army Corps of Engineers to conduct a feasibility study. The costs fluctuated over the course of the next decade as the scope of the project changed. In 1999, the Corps carried out a project to deepen the shipping channel of the Columbia River from 40 to 43 feet, extending from Astoria to Portland. A coalition of ports and businesses that use the river pushed hard for this deepening so as to allow access by larger ships. Pictured is the Port of Portland dredge *Clackamas* working in Columbia's shipping channel near Longview, Washington. The picture was taken over the corner anchor barge and shows the dredge swinging on its port spud. The aerial seen here is for a television set in the crew's lounge. (Courtesy of Peter Marsh.)

Three

THE LIBERTY AND VICTORY SHIPS OF WORLD WAR II

During World War II, many emergency shipyards were generated to build for the war. Created in February 1942, the US War Shipping Administration made its first priority to warrant the design of warships that came to be known as the Victory class. By 1941, the Oregon Shipbuilding Corporation was established in Portland to build and repair both Liberty and Victory ships. Over 1,000 of these vessels were built there from 1941 to 1945. Overall, 18 American shipyards built 2,710 Liberty ships between 1941 and 1945—the largest number of ships produced for a single design.

Built in the United States just for World War II, the Liberty ship's design was based on a cargo ship structure. Britain had created the original design, which the United States then adapted for inexpensive and efficient manufacturing. Based on vessels ordered by Britain to replace ships torpedoed by German submarines, they were purchased for the US fleet and for lend-lease deliveries of war material to Britain. Twenty more of them were sent to the Soviet Union under the lend-lease program.

A Victory ship was a particular build for a cargo ship to replace lost haulers destroyed by German submarines. They were larger than Liberty ships, at 455 feet long, 62 feet wide, and a draft of 28 feet. The Victory ships could move fast in the water with a fine, raked bow and a cruiser stern, giving them quite a different appearance. These ships were quick to build with powerful engines, designated as EC2-S-AP1, where "EC2" stood for emergency cargo, type 2 (load waterline length between 400 and 450 feet), and "S" indicated steam propulsion with one propeller. The difference between the two ships was their design. Liberty ships were EC2-S-C1; this was changed to VC2-S-AP1 before the Victory ship name was officially adopted on April 28, 1943. The Oregon Shipbuilding Yards delivered 455 ships to the US Maritime Commission, which closed after the war.

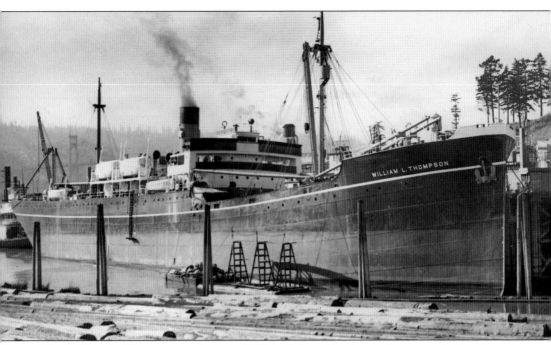

The *William L. Thompson* was built in 1920 by Schaw, Batcher & Company in San Francisco, California. She was 427 feet, and the only wood on her main deck was in the kitchen. She was acquired on a sub-bareboat contract from her owner, the Thompson Salmon Company, on February 14, 1942. She was then transported to the US Army in Baltimore, Maryland. She left in March for Norfolk, Virginia, and sailed to Seattle via the Panama Canal, stopping in San Francisco. In June, she began regular service from Seattle to Alaskan ports, including Seward, Valdez, Ketchikan, and Kodiak. She would continue in this service for nearly four years. In December, she collided with the SS *Pacific Oak* and was dry-docked for bow repairs. On February 12, 1946, she returned to the War Shipping Administration while at Portland. On that same day, she was sent to the Pacific Atlantic Steamship Company. On May 6, 1946, she was released to her original owners. (Courtesy of Peter Marsh.)

The Merchant Marine Act was passed in 1936. The goal of this act was to subsidize the yearly assembly of 50 commercial merchant ships to be used in wartime by the US Navy. This number doubled in 1939 to 100 and again in 1940 to 200 vessels a year. These warships included tankers and three types of merchant vessels, all to be motorized by steam turbines. Because of the limited manufacturing capacity, especially for reduction gears, very few of these ships were ever built. That changed with World War II. The Oregon Shipbuilding Corporation was created as an emergency shipyard in the St. Johns area of Portland between 1941 and 1945. This shipyard was one of three Kaiser Shipyards in the area. The second was the Swan Island Shipyard, also in Portland, and the third was at Ryan Point, Vancouver, Washington. During this time, over 1,000 Liberty and Victory ships were built in the northwest. (Courtesy of Peter Marsh.)

Here is the US Army transport ship the *Rosecrans* docked in Portland around 1900. She was built in Glasgow, Scotland, in 1883, at 2,976 gross tons. Most of these government-owned ships of the period were named after Civil War generals. (The *Rosecrans* was named after Gen. William S. Rosecrans.) There were almost 20 of these transport ships built, and most served in the Pacific before World War I. A sad ending to the *Rosecrans* came a year after the war when she was returning to Portland from California: as she was approaching the Columbia River, she got caught in a gale storm and lost her ability to stay afloat. While on the bridge, the second officer mistook the North Head Lighthouse for the lightship, and the tanker bore head-on up and over the south jetty. By the next morning, there was little left of the *Rosecrans*. (Courtesy of Oregon Maritime Museum.)

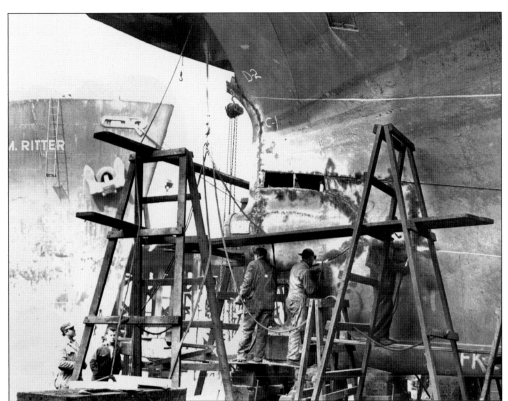

During World War II, the United States created (or consigned) shipyards to build mass-produced ships called Liberty ships. Eighteen American shipyards, two of which were in Portland, built over 2,700 Liberty ships between 1941 and 1945, easily the largest number of ships produced to a single design. Pres. Franklin D. Roosevelt, who admired naval ships and had a gift for design, was pleased with the production. He was known to comment on these vessels as strong and able to carry a heavy load, but not much to look at. So the Liberty ships received their nickname, "the Ugly Ducklings." Regardless of their appearance, a quick industry developed to build these ships, and many survived much longer than the original design life of five years, making these vessels a strong mark in our history. (Above, courtesy of Vigor Industrial; right, courtesy of Peter Marsh.)

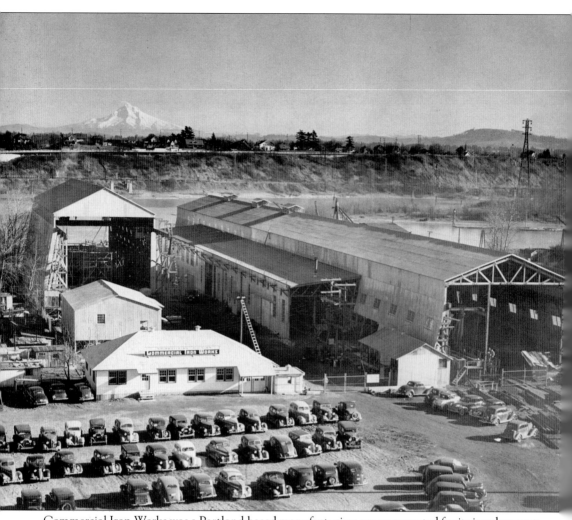

Commercial Iron Works was a Portland-based manufacturing company noted for its involvement in the World War II emergency shipbuilding program. William T. Casey, Otto J. Hoak, and Robert Boogs established the company in November 1916 on the Willamette River, just south of the Ross Island Bridge. On this 30-acre site, the company took on many different services, such as in 1927 when it placed a bid for the manufacture of 200 fire hydrants for the City of Portland. The company is recorded as having built only one ship before World War II—a small 140-ton tender for the US Coast Guard in 1935. Commercial Iron Works established a shipyard on the Ross Island site in the early 1940s, which turned out close to 200 small warships during the war, counting netlayers, minelayers, submarine chasers, and LCI (Landing Craft, Infantry) and LCS (Landing Craft, Support). It also outfitted larger ships built at other yards with armaments. In 1946, the Zidell Machinery & Supply Co. obtained this shipyard. (Courtesy of Peter Marsh.)

It is hard to overemphasize the effect that World War II–era shipbuilding had on the Portland-Vancouver area. According to records kept by the US Navy during this time before the war, most area shipbuilding activities involved the construction of small fishing vessels, tugboats, and barges. But as the Nazis began their conquest of Europe, the federal government began sending money to shipyards along the East and West Coasts, originally to produce ships for the British government and then, after the Japanese attack on Pearl Harbor, for the US war effort. In Portland, the government worked with a number of existing companies on Swan Island, including the Albina Engine and Machine Works Inc., Commercial Iron Works, Portland Shipbuilding Co., and Willamette Iron and Steel Corp. The Gunderson Brothers Engineering Corp. also boosted the size of its plant to build small vessels. (Courtesy of Vigor Industrial.)

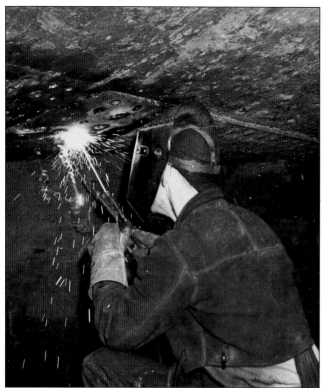

Liberty ships were renowned for their all-welded construction and extensive use of prefabrication. The production line techniques used to build these ships were not new, as the same procedure was also used in World War I. Still, these techniques resulted in a production rate far in advance of what was thought possible before the second World War. The first Liberty ships required about 230 days to build (the *Patrick Henry* took 244 days), but the average time ultimately dropped to 42 days. The *Robert E. Peary* set the record, launching just four days and 15.5 hours after the keel had been laid. The Oregon Shipbuilding Corporation in Portland built many Liberty ships. The SS *Joseph N. Teal* was built in just 10 days. (Both courtesy of Peter Marsh.)

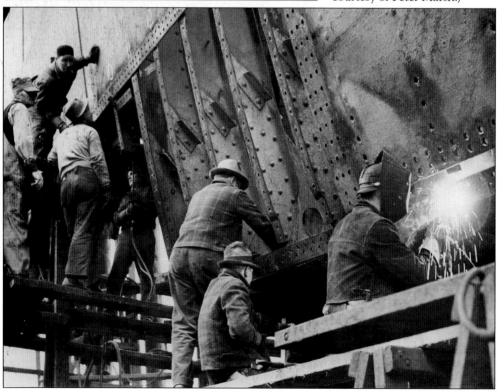

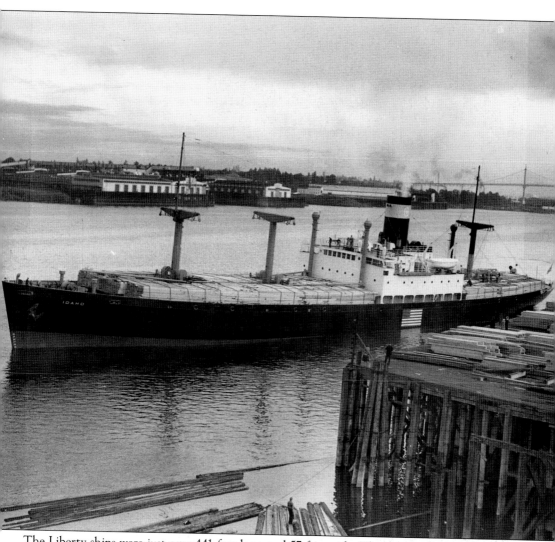

The Liberty ships were just over 441 feet long and 57 feet wide. They used a 2,500-horsepower steam engine to move at 11 knots (approximately 12.5 mph), with a range of 17,000 miles. They had five cargo holds—three forward of the engine room and two to stern. Each one could carry 10,800 tons of cargo, or 4,380 net tons (the amount of space available for cargo and passengers). The crew quarters were located in the middle portion of the ship (amidships). Many technological developments were made while building these ships. In order to save steel, a cold-rolling process was developed, making the cargo booms lighter. Welding techniques also increased the production of the first all-welded ships. Prefabrication was perfected, with complete deckhouses, double-bottom sections, stern-frame assemblies, and bow units, speeding up production of the ships. By 1944, the average time to build a ship was 42 days. In all, more than 2,700 Liberty ships were built between 1941 and 1945, making them the largest class of ships built worldwide. (Courtesy of Peter Marsh.)

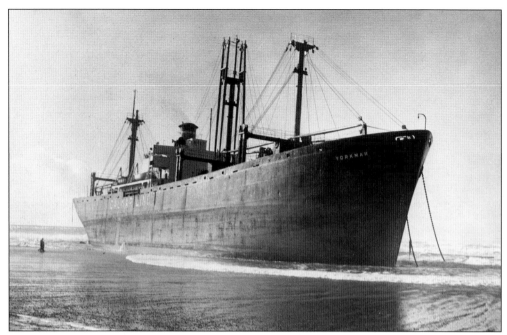

The 10,000-ton *Yorkmar* was originally the *Walter Kidde*. She was a Liberty ship built at the Bethlehem-Fairfield Shipyard in Baltimore, Maryland, in 1944. After World War II, she was bought by Bethlehem Steel Company, one of the largest steel producers and shipbuilders in America and headquartered in Quincy, Massachusetts. She was used to ship steel to the West Coast and take wood back to the East Coast for Bethlehem Steel. Zidell Explorations Inc. of Portland scrapped the *Yorkmar* in its Tacoma yard in 1966. These photographs were taken when she went aground on December 11, 1952. (Both courtesy of Peter Marsh.)

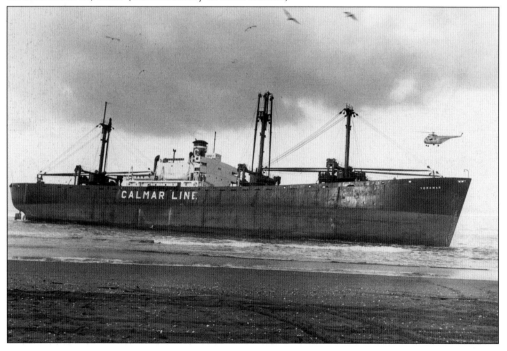

The third Liberty ship, named the *William Hodson*, was built in 1944 in New York. After her service during World War II, in 1947, she was taken in by West Coast Trans-Oceanic (also known as the West Coast Steamship Company) in Portland and renamed the *Oregon Trader*. In 1956, she operated as a merchant ship in the supply effort with the US Navy in the war zone during the Korean War. After the war, Zidell Explorations Inc. picked up the *Oregon Trader* in 1962. She was scrapped for her metal in Portland in 1963. Below is an unidentified Zidell workman with the Zidell scrapyard behind him. (Above, courtesy of Peter Marsh; below, courtesy of Zidell Marine.)

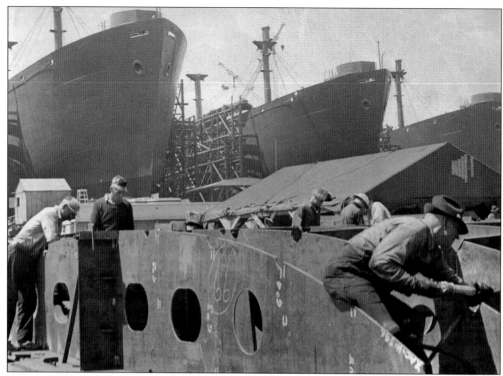

When the United States entered World War II at the end of 1941, it was ready for war. But with German U-boats raiding the shipping lanes and hunting both British and American merchant ships, a new program had to be developed. The Liberty ships were too small and too slow, their maximum speed only 11 knots; they were unable to deliver the necessary supplies both countries needed to win the war. In 1943, America launched a new shipbuilding plan. The Maritime Commission called this new design the Victory ship. These new ships were slightly longer than the Liberty at 455 feet in length and 62 feet wide, making them larger, faster, and able to carry much more freight. Built in California, the *Pine Bluff Victory* is shown docking on the Willamette River. (Both courtesy of Peter Marsh.)

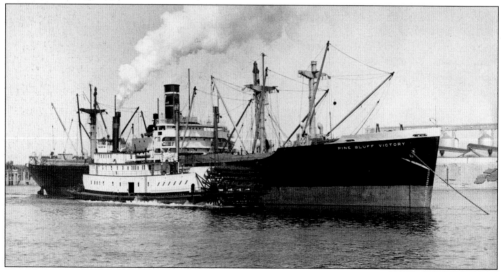

An unfortunate and unforeseen design flaw caused hull fractures with the initial group of Liberty ships. The cause was finally tied to their rigidity. In order to correct this issue in the new Victory ships, the hulls were built with frames on 36-inch centers as opposed to the 30-inch centers that the Liberty was based on. This alteration made these ships more stable, and they had two enlarged tanks at the back of the engines that carried fuel, dry cargo, or saltwater ballast, which did away with the need for a fixed stabilizer. (Both courtesy of Peter Marsh.)

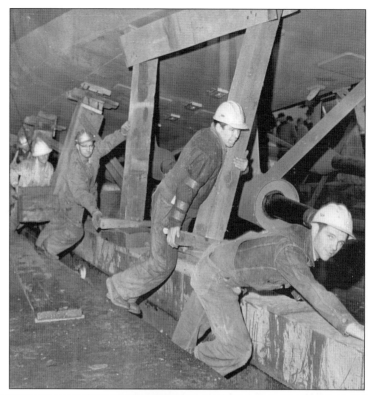

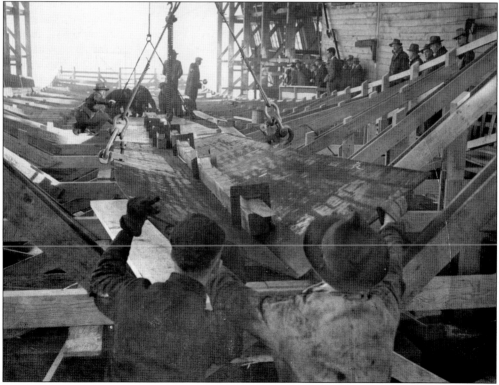

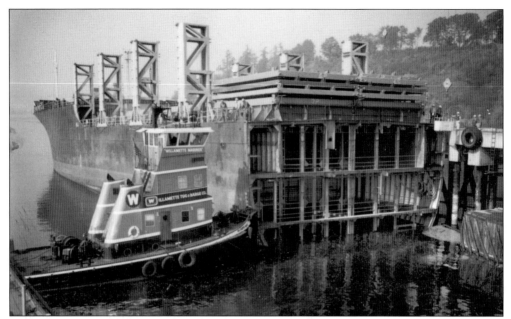

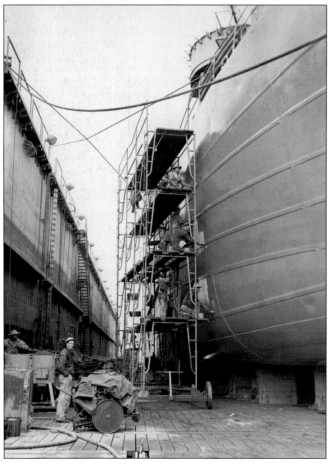

The successful assembly of both the Liberty and Victory ships was in the production. Under the remarkable leadership of Henry J. Kaiser, these yards were laid out along the same format as assembly plants for the 30,000-plus components, produced in thousands of factories in more than 32 states. Modular construction techniques were invented, which changed the face of shipbuilding forever. Portable units for continuous welding were developed, and conventional tools and methods were abandoned. Shipbuilding technology progressed by at least 20 years during this period, and the labor requirements were reduced by about one-third of those previously required in the construction of similar ships. (Both courtesy of Vigor Industrial.)

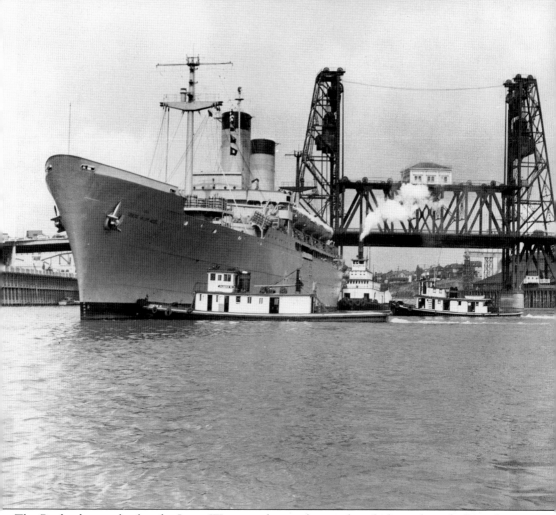

The *Portland* sternwheeler, the *James W.* tug, and one other unidentified vessel are docking the USS *Gen. William Weigel* on the Willamette River in Portland. The *Weigel* (AP-117) was a troop transport that served in many wars. She worked during World War II, after which the US Army took her and changed her to the USAT *Gen. William Weigel.* From October 6, 1945, to February 8, 1946, she made three round-trip transpacific voyages (two out of San Francisco and the third from Seattle) to bring occupation troops to Yokohama, Japan. During the Korean War, she was sent to the Military Sea Transport Service (MSTS) and labeled the USNA *Gen. William Weigel* (T-AP-119), a title she held for her service in the upcoming Vietnam War. She continued to interchange American troops to strengthen the United Nations position in Korea until she was placed in Reduced Operational Status in 1955. She carried troops to the Vietnam War from 1965 through 1967. *Gen. William Weigel* received seven battle stars for the Korean War and one for the Vietnam War. (Courtesy of Peter Marsh.)

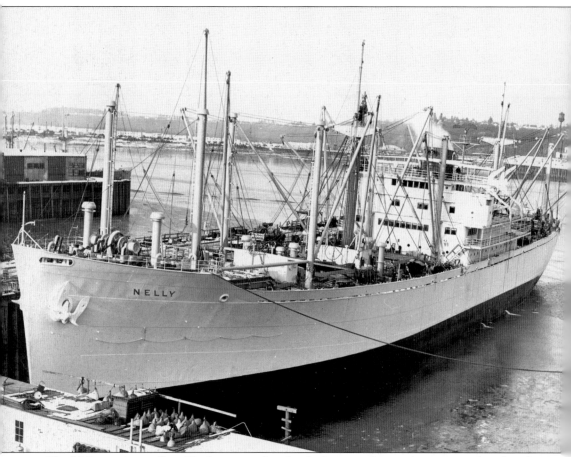

The *Nelly* was originally a C3-class cargo ship, but before completion, she was transferred to the US Navy. Once there, she was made into an auxiliary aircraft carrier, the USS *Long Island*, and decommissioned on March 26, 1946. Removed from the Naval Vessel Register on April 12, she was sold to the Zidell Ship Dismantling Company in Portland for scrapping. Instead, on March 12, 1948, the Canadian-Europe Line purchased her for conversion into merchant service. Once renovated in 1949, she was renamed the *Nelly*. She worked as an immigrant carrier between Europe and Canada. In 1953, she was renamed the *Seven Seas*. In 1955, she was chartered to the German Europe-Canada Line, with her last journey in April 1963. On July 17, 1965, she had a damaging fire and was towed to St. John's, Newfoundland, where she was repaired and continued to work until September 1966. She was then purchased by Rotterdam University, Holland, and was used as a student hostel until 1977, when she was scrapped in Ghent, Belgium. (Courtesy of Peter Marsh.)

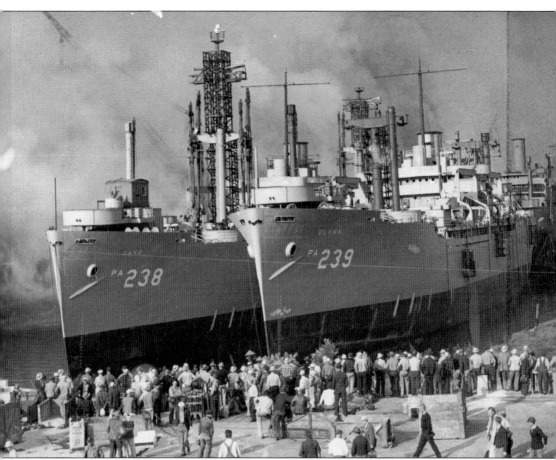

Here are two Haskell-class attack transport (APA) ships, which were made for amphibious assault. Haskell-class ships were Victory ships designed by the US Navy especially to transport 1,500 troops and their combat equipment, then land them on enemy shores with their vital landing craft. Ships of this class were among the first Allied crafts to enter Tokyo Bay at the end of World War II, landing the first occupation troops at Yokosuka. These two ships were built during World War II but never saw any action. The USS *Dane* was named after a county in Wisconsin, and the USS *Glynn* was named after a county in Georgia. The *Dane* was launched on August 9, 1945, and the *Glynn* on August 25, 1945, both under the Maritime Commission contracted by the Oregon Shipbuilding Corporation in Portland. The *Dane* was commissioned on October 17, 1945, with Comdr. Ben Koerner, USNR, in command, and the *Glynn* on October 29, 1945, with Capt. D.K. Day in command. (Courtesy of Oregon Maritime Museum.)

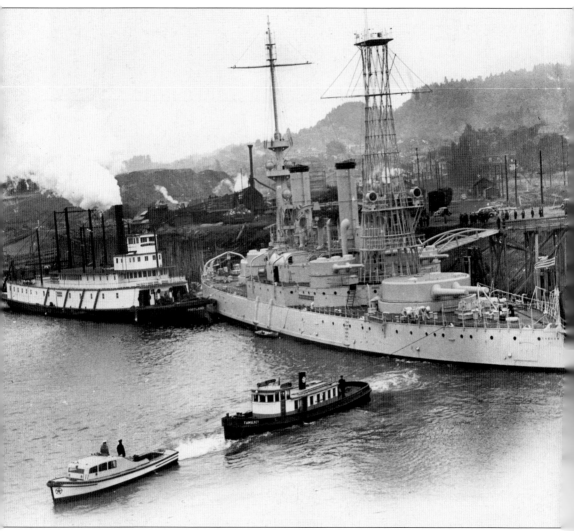

Here are the *Portland* sternwheeler and the *F.W. Mulkey* tug docking the USS *Oregon* battleship at the foot of Southwest Jefferson Street. The *Oregon* was built in 1895 and was the only battleship serving on the US Pacific seaboard. In 1898, she was sent to steam around South America. She served off Cuba and played an important role in the Battle of Santiago on July 3, 1898. During World War I, she guarded the Pacific coast and escorted a troop convoy to Siberia. She was decommissioned in 1919 and was loaned to the State of Oregon as a museum ship. She was sold for scrap in 1956. All that remains of her today is the mast and two funnels. The mast highlights the Battleship Oregon Memorial at Tom McCall Waterfront Park, in downtown Portland. The funnels are being stored. (Courtesy of Peter Marsh.)

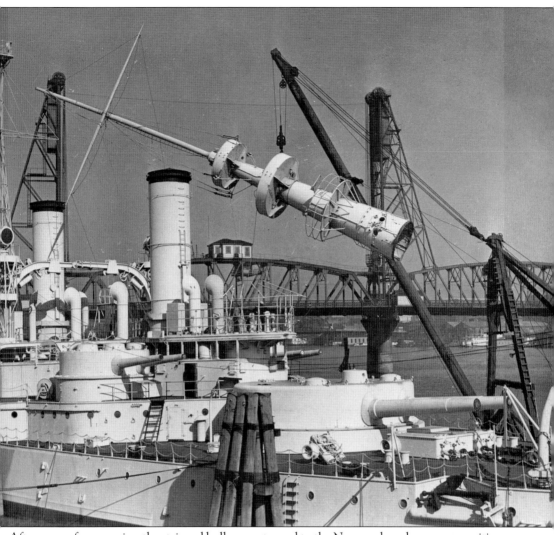

After years of war service, the stripped hulk was returned to the Navy and used as an ammunition barge during the Battle of Guam. There, she remained for several years. One year after the attack on Pearl Harbor, a parade commemorating the ship marched through downtown Portland. Congressman Lyndon B. Johnson delivered a speech, and the front page of the *Oregonian* newspaper included a 15-stanza ode to the ship. A memorial was erected with her mast in Portland in 1956 to remember this "Bulldog of the US Navy." On July 4, 1976, a time capsule was sealed in the base of this memorial. The time capsule is to be opened on July 5, 2076. The mast hatch door to the time capsule is padlocked, but there is a clear glass porthole on the west side that allows a view of the time capsule. The *Oregon's* two funnels were displayed in Portland's Liberty Ship Memorial Park. In 2006, the funnels were put into storage, as the park became part of the Waterfront Pearl condominium development. (Courtesy of Peter Marsh.)

The USS *Blueback* (SS-581) was launched on May 16, 1959. She earned two battle stars for her Vietnam War service. She was the last non–nuclear powered, fast-attack submarine built by the US Navy. She was also the final one to be decommissioned after serving her country in official operation throughout the Pacific Ocean for 31 years. Along with her sister ships of the Barbel class (the last diesel-electric-propelled attack submarines built by the US Navy), these battle-ready submarines utilized radical new concepts in post–World War II undersea design, the most important being the teardrop hull and a single propeller. After her retirement, the USS *Blueback* performed in the entertainment industry by appearing in the movie *The Hunt for Red October* and an episode of *Hawaii Five-O*. She has also been used as a location for a Discovery Channel documentary and many commercials. She is currently located at OMSI. (Courtesy of Oregon State Library.)

Four

SUNKEN SHIPS
IN PORTLAND

As more people came to Portland along both the Columbia and Willamette Rivers, more hardships ensued on the water. Steamboats on the Columbia River system were destroyed for various reasons, including striking rocks, logs, or snags. A fire on the boat, a boiler explosion, or a puncture (often by ice) could also shatter the hull. Ships had the same risks and scenarios. Collisions occurred between vessels most often near landings, sometimes without serious loss. One collision occurred on December 26, 1913, when the sternwheeler *Oregona* struck an anchored barge on the Willamette River and sank. Another steamboat, the *Oregon*, hit a snag on the Willamette in 1854, was bumped loose by the sidewheeler *Gazelle* (herself later to explode in Canemah), then drifted downstream, hit a rock, and sank to the bottom. On December 30, 1907, the barque *Europe* butted the steamboat *Annie Comings* on the Willamette River near St. Johns; she sank in three minutes, luckily with no loss of life. Fire was so common a source of destruction that, in some cases, little information was available as to the cause, like the *J.N. Teal*, which burned in Portland on October 22, 1907. Sometimes vessels could be salvaged, and sometimes not. In this chapter is a story of one ship that capsized and sank in 45 feet of water next to the Portland dry dock. It was abandoned by its captain and left under the care of the US district engineer. Since the ship could have sunk under the pier and jammed up against the dry dock, the engineers had to hire a contractor to remove the vessel. Two methods were examined for this ship: the first was to cut it up using underwater torches and removing it in sections; the other was to patch its holes, blow air into the hull, and float it out. Several contractors submitted bids, but that of Gilpin Construction Company of Portland was accepted. The following is their story.

The 49-year-old, 390-foot, 5,000-ton Russian freighter *Illitch* capsized and sank in 40 feet of water just next to the St. Johns dry dock on June 24, 1944. The ship was moored in Portland for repair from its war service on the Pacific Ocean. The cause of the disaster was not immediately known even though divers were sent down to check all the holds and sea valves for the Board of Marine Underwriters. They were unable to search much of the starboard side, as it was deeply entrenched in the mud. The trouble began around 4:30 that morning when the ship began to list. Many of the crew had heard a popping sound, which could have been from a plate caving in, a line snapping, or a pile breaking on the dock where the lines holding the ship had tightened. Within 30 minutes, she was on her side and dropping slowly into the Willamette. When she finally sank, only a few inches of her port side showed above the river level. (Courtesy of Peter Marsh.)

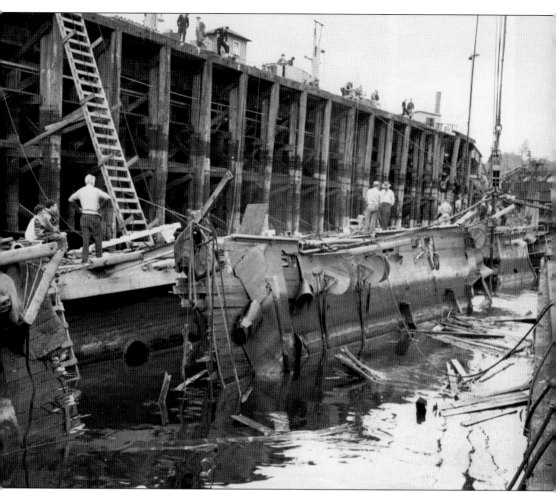

Divers were called on to recover the sunken ship. Marine salvage is the process of retrieving the vessel itself as well as its freight and other property. Saving the cargo and equipment aboard the *Illitch* was the first task. Any goods that presented an environmental hazard or any expensive materials, such as machinery or precious metals, had to be removed first. To accomplish this quickly, concerted effort was placed on the express removal of properties, which included deliberate dissection, disassembly, and finally, destruction of her hull. When the purpose is not to restore the ship, the wreck is usually refloated or removed by the cheapest and most practical method possible. The most common techniques used in wreck removal are cutting the hull into easily handled sections or refloating the vessel and scuttling it in deeper waters. (Courtesy of Peter Marsh.)

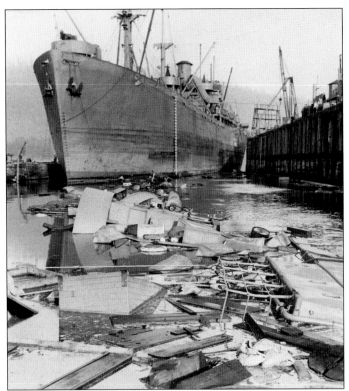

Much of the debris floated to the surface after the vessel capsized. The *Illitch* had a beam of 45 feet and was almost completely submerged. The Russian crew members scrutinized the remains of their sunken ship from the safety of land. The men were sent home on another Russian vessel, which was there loading cargo to take back to Vladivostck. Soon after the wreck, Russian transport officials also examined the loss of the ship at the Portland dry dock. They never did determine the cause of the accident, which drowned a female cook, while 58 other crew members and several Portland workmen escaped. (Both courtesy of Peter Marsh.)

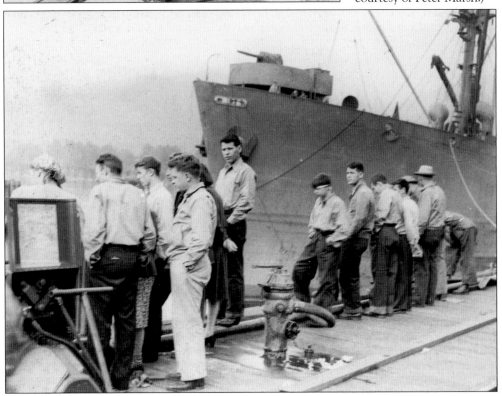

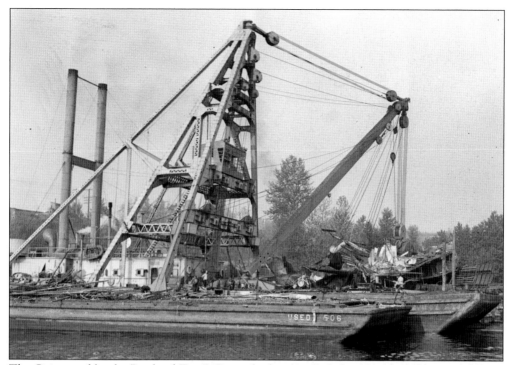

The *Cairo*, used by the Portland Tug & Barge, had originally helped build the Mississippi River levees and was one of the world's largest floating derricks. She was sent out to stack sections of the damaged steamer on a Willamette River bank near the Portland dry dock. Junk dealers and merchants took the salvaged sections of steel to sell to scrap mills. (Courtesy of Peter Marsh.)

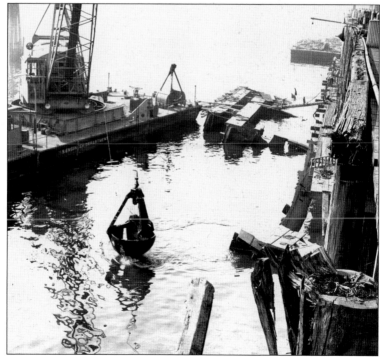

Gilpin Construction sent out a pile driver to send some heavy pile dolphins under the water next to the sunken SS *Illitch* so that lines could be attached around the ship to keep it from sliding under the dry dock pier. All agreed to move this damaged vessel as quickly as possible so the pier could be used for future maritime repairs and conversions. (Courtesy of Peter Marsh.)

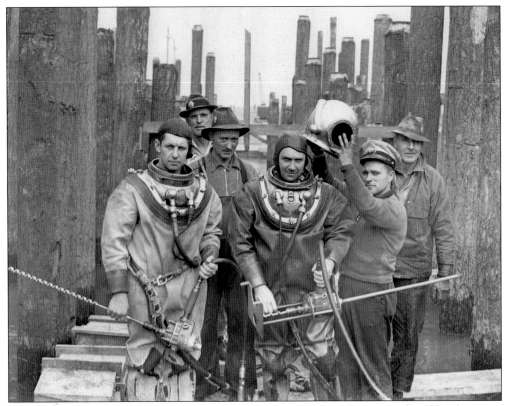

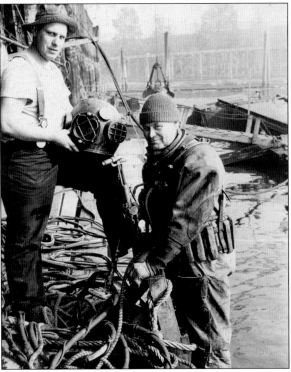

These divers, employed by the Columbia River Salvage Company (Fred Devine and Art Zimmerman), are preparing to go underwater to dismantle the *Illitch*. Above, Bob Patching, the center diver, oversaw the underwater salving of this ship. Eight Navy divers were brought in from New York to help dismantle the sunken ship. The divers are carrying underwater burning torches to the bottom of the river to cut the sunken 400-foot steel ship into pieces. The key to this salvage was to cut the hull using a special cable. The rest of the wreck got the same treatment, from the engine room to the cargo hold. At left, John Ulrich, the tender, fits Patching's helmet and lights his torch before he goes below. (Both courtesy of Peter Marsh.)

In August, the salvage job was put out for bid. The submissions must have been too steep, as the work was turned over to the US Army Corps of Engineers in October. Since the hull was almost 50 years old, it was not worth saving and was to be cut up by hard-hat divers. At right, Bob Patching is about to descend into the water to work on the capsized ship, resting on the bottom of the Willamette River beside the Port of Portland dry dock. Capt. J.I. Tooker, a Navy salvage specialist in charge of operations, stands behind the tenders, advising the men on the work process. The sunken ship would be dismantled through underwater burning and ripped apart where she lay; what could be salvaged would be brought ashore and sold as scrap. (Both courtesy of Peter Marsh.)

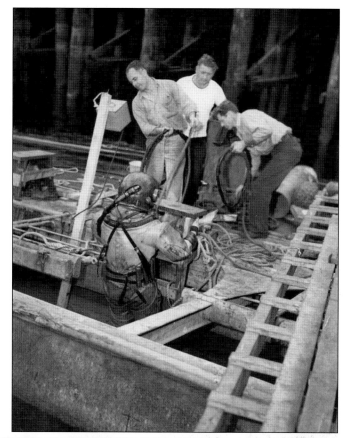

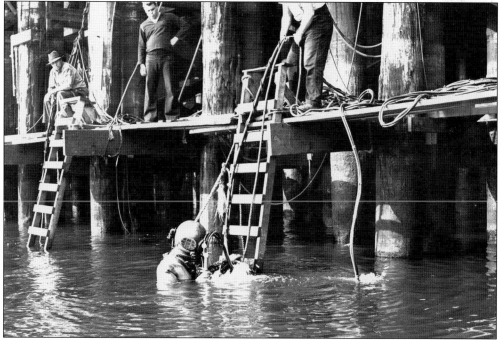

Bubbles on the surface of the river were the only sign of the divers cutting the ship below. The bubbles came from the exhaust valves in the rubber suits worn by the divers and from their hydrogen-oxygen burning torches. All of these pieces have to be tethered and pulled up by the derrick barge. (Left, courtesy of Peter Marsh.)

A nearly 150-ton piece of the stern was raised from the Willamette River near the dry dock and laid on the riverbank about a quarter of a mile upstream by the *Cairo* derrick. It included the stern frame, rudder, propeller, and a portion of the *Illitch*'s stern shell plate and deck, as well as the gun mount. Once delivered, the gun mount soared 60 feet in the air. (Below, courtesy of Peter Marsh.)

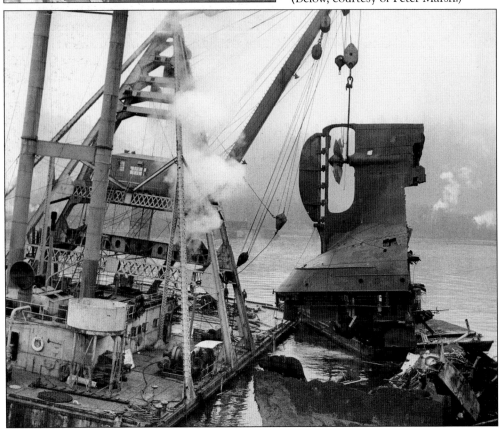

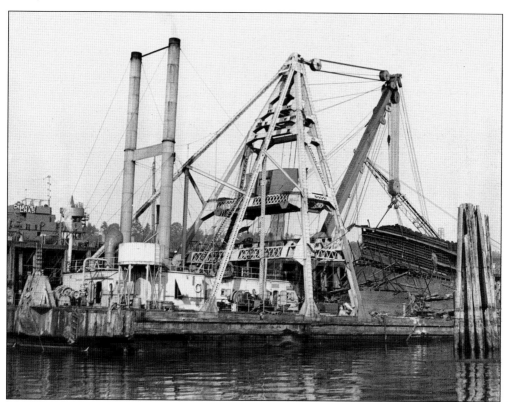

The largest section of the ship to be recovered was the 200-ton bow. Other pieces retrieved were portions of the decks, side shell, and bottom tanks. The divers had to begin their work by removing machinery and fragments that blocked access to their main operation. The danger for these divers did not rest solely underwater, but extended to the ongoing surface activity as well. Therefore, Karl Prehn, the Portland harbormaster, requested for boats passing through to run at slow bell so their wash would not harm the divers below. About a quarter of the ship was salvaged, and the divers on this job were able to cut up about one-third of the wreck. (Both courtesy of Peter Marsh.)

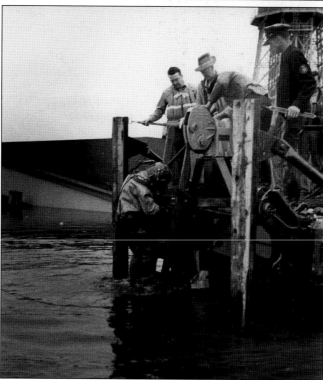

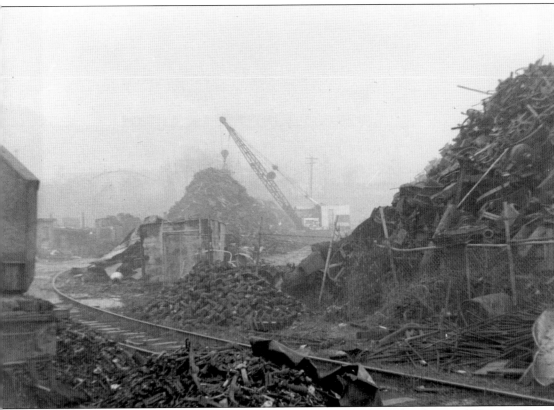

Early Oregonians were not above looting stranded or wrecked vessels. This would later evolve into a legitimate business model, and proper recycling of derelict vessels continues to this day. Back when the maritime trade still relied on wooden barges for the transport of goods, Emery Zidell had the notion to turn the scrapped remains of steel ships into new steel barges. Later, Zidell would build some of the first double-hulled steel barges. It is quite likely that elements of the doomed SS *Illitch* survive today in the form of a custom steel Zidell barge. This photograph shows a typical day at the yards of Zidell Marine Corporation, with sifting and sorting of the various recovered materials. Just to the left of the pile being worked by the crane, Portland's Ross Island Bridge (completed in December 1926) is barely visible through the fog. (Courtesy of Zidell Marine Corporation.)

Five

THE FRED DEVINE DIVING AND SALVAGE COMPANY

The Fred Devine Diving and Salvage Company (FDDS) has been a leader in diving and construction for nearly a century. The present-day corporation grew from a diving company started by Fred Devine in the Swan Island Lagoon in Portland in 1913. It specializes in both heavy and light marine salvage, wreck removal, high-capacity and heavy oil pumping, underwater inspections of vessels and structures, underwater repair, environmental dredging and sampling, and receiving and delivery of ship stores. The star of the company is the *Salvage Chief*, specially designed to operate under conditions common on the Pacific Northwest coast and Alaska. Fred Devine knew firsthand what was needed for salvaging lost crafts and cargo from both the Pacific Ocean and its rivers. He had toyed with creating his own salvage vessel from a wooden barge with a 200-horsepower diesel engine and a steam donkey to power the winches. Soon after World War II, Devine took advantage of the number of wartime ships being unloaded by the US government. He bought a 203-foot-long, 34-foot-wide, 9-foot draft LSM (Landing Ship, Medium) in September 1948. The original ship was designed for landing troops and mobile equipment upon the sandy beaches of the South Pacific during World War II. The LSM hull lay idle until Devine had enough money to create his dream salvage vessel. The Kaiser-operated Consolidated Builders Inc. (CBI) performed most of the work on Swan Island, where CBI was busy scrapping a fleet of LST (Landing Ship, Tank) vessels that had come back from the war in bad condition. Devine scrounged through these vessels and picked out several large winches that had hardly been used. The diesel generators Devine installed also came from these old LSTs. By 1949, the *Salvage Chief* was ready to prove herself—which she did in every job assigned to her. Over the years, Devine equipped the *Salvage Chief* to handle every possible situation, from firefighting to refloating. Today, the famous *Salvage Chief* is moored on the FDDS wharf in Portland.

Underwater commercial building, salvage, repair, and rescue require divers to go below the surface. With bungling airlines and gear, early divers had to wear cumbersome dive helmets and suits. All work before the mid-1930s was performed with hand tools. Compressors were hand-pumped by two men on deck. The commercial helmets of the 1920s and 1930s often weighed more than 50 pounds and were usually made of copper and brass, with the weight distributed across the diver's shoulders. This Andrew J. Morse & Son Inc. helmet (left) was made in Boston, Massachusetts, but was very popular with some divers in Portland. Capt. K.A. Prehn of the Columbia River Harbor Patrol is shown below in a typical dive suit worn in 1938. (Both courtesy of Peter Marsh.)

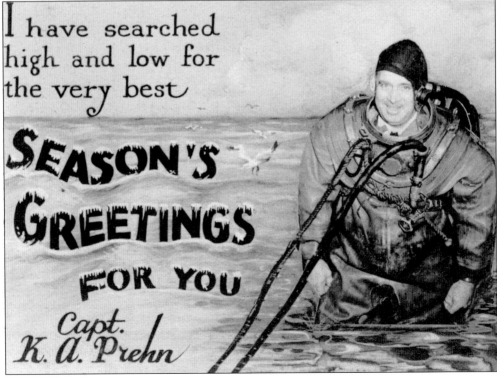

I have searched high and low for the very best SEASON'S GREETINGS FOR YOU Capt. K. A. Prehn

The first commercial divers (right) in Portland—such as Clyde Lieser, Walter Sterling, Art Zimmerman, and Fred Devine—used diving suits that comprised a metallic (copper, brass, and/or bronze) diving helmet, an airline or hose from a surface-supplied air pump, a canvas diving suit, a diving knife, and weighted boots. It was not until World War II that diving suits were made of rubber. This type of gear is known as hard-hat equipment. Today, commercial divers (below) may still use an umbilical air supply from the surface, and depending on the location of the work, divers may use wet suits, dry suits, or even hot-water suits, depending upon the temperature of the water. All these modern updates are used at Fred Devine Diving and Salvage Company in Portland. (Both courtesy of Peter Marsh.)

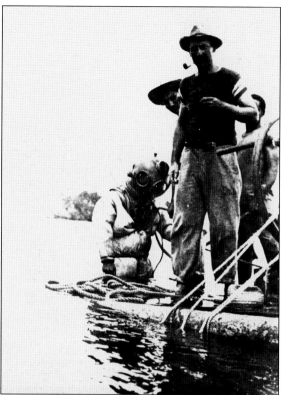

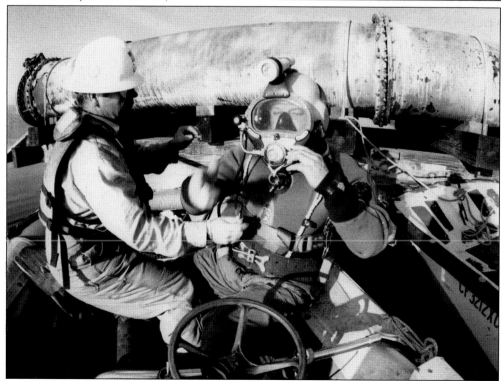

Fred Devine and three brothers grew up in the family home on the north shore of the Columbia River, behind Lieser Point in Washington. At 13 years old, Fred was working for Clyde Lieser on his gillnet fishing boat. A year later, Lieser trained Devine to snag dive. (Snag diving is descending to the bottom of the river where fishing nets have been dropped. When branches or rocks catch in a gillnet, a diver is sent down to free the snag.) He bought his young partner a dive helmet and suit. From the guidance Lieser provided Devine, Fred quickly became a skilled diver. When the states of Oregon and Washington hired workers for the Interstate Highway Bridge between Hayden Island and Vancouver, Devine applied as a diver to assist in the underwater pier construction and inspection. By the time he turned 16, Devine had saved enough money to buy his own diving business, the Sterling Diving Service, from a retired diver, Walter Sterling. From then, Devine soon became the Northwest's best-known salvage diver. (Courtesy of Peter Marsh.)

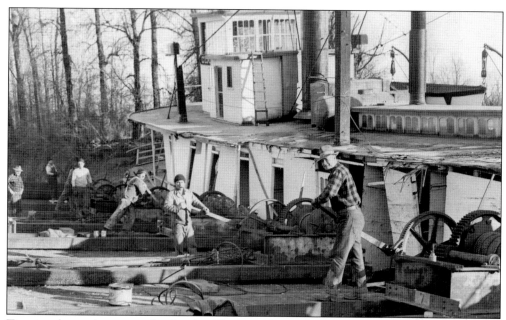

To raise the sunken sternwheeler the *Claire* on the Willamette River, Fred Devine and Art Zimmerman, owners of the Columbia River Salvage Company, had to use a combination of timbers, chains, and house jacks. The chains were passed under the boat and fastened on the outside edge of barges lying along both sides of the *Claire*. It took four men to lay out the jacks and carefully raise the heavy sternwheeler from off the river bottom to pump out the water-filled hull. The boat was later dismantled, scrapped, and burned on the water—a sad end to a boat that put in 32 years of hard work. (Both courtesy of Peter Marsh.)

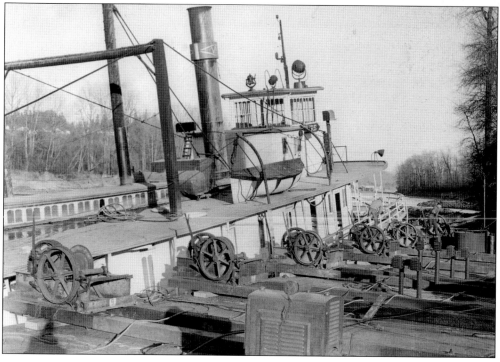

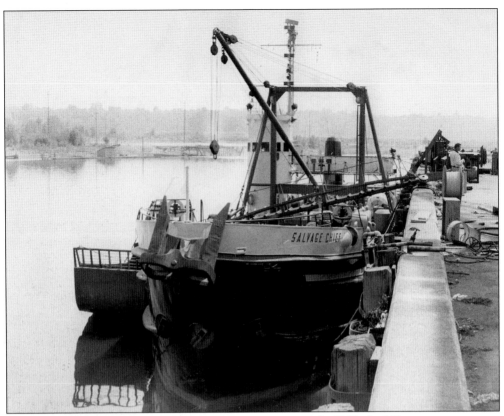

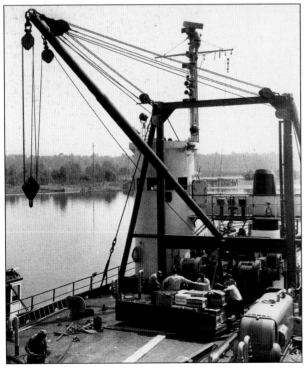

In 1948, the US government discharged much of its wartime fleet at scrap prices much less than their original cost. Devine knew he could convert one of those LSMs into his own salvage vessel. He bought an LSM and converted it into his dream platform. From his first use of the *Salvage Chief* in 1949 to the present, the *Chief* incorporates six salvage winches below decks, three leading forward, and three aft. Her shallow draft and full lines let her lie for an indefinite period of time in the heaviest surf conditions. If special parts or tools are required for any job, there is a fully equipped machine shop, plus two workshops with a full inventory of all necessary salvage equipment on board. All salvage equipment is arranged for quick helicopter transfer to distraught crafts. (Both courtesy of Peter Marsh.)

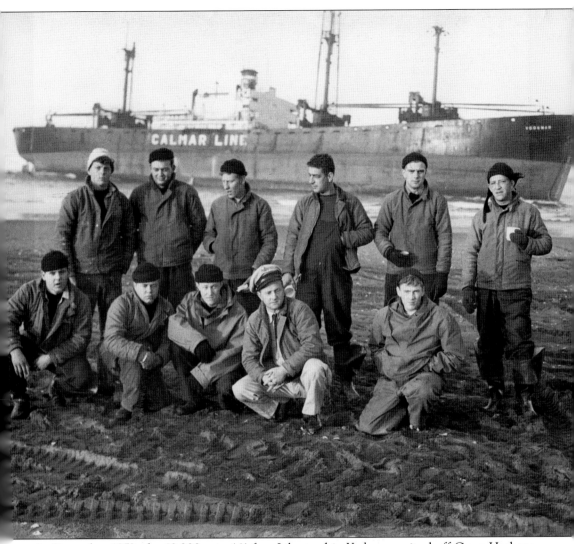

In December 1952, the 10,000-ton, 441-foot Liberty ship *Yorkmar* arrived off Grays Harbor, Washington. The weather was so bad that the ship steamed around in circles for two days waiting for a break that would allow her to moor. When a big breaker hit her, the *Yorkmar* dropped anchor, but she was driven broadside into the water. At low tide, the 36 crew members were able to get ashore. Recovery seemed hopeless, thus Fred Devine and his *Salvage Chief* were called to the rescue. The *Chief* stopped 4,000 feet from the *Yorkmar* and dropped anchor. Capt. Vince Miller allowed the ship to drift in until it was just 1,500 feet from the *Yorkmar*. They could not secure her, so they reluctantly returned to shore. Four days later, the *Chief* returned when the sea was calm. Three anchors and two towlines were set, and the tension was taken up. Using the slight motion of the *Yorkmar* at high tide, the *Chief* began to move her. Ten days later, the *Yorkmar* was able to steam to Portland for dry-docking. (Courtesy of Peter Marsh.)

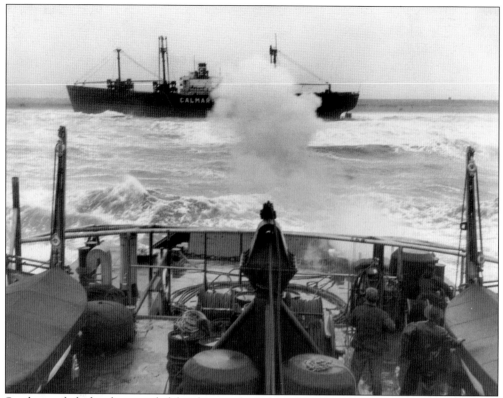

Smoke partly hides the stranded freighter as the *Salvage Chief*'s crew fires a Lyle gun to lay lines across the *Yorkmar*. Devine struggled to get a small line across so that larger lines could be used to pull the *Yorkmar* over before securing a heavy steel towline. Three shots failed, but a line was finally floated over by barrel. (Courtesy of Peter Marsh.)

Paul LaMade, the *Salvage Chief*'s electrician, worked as a winchman on a lower deck at the controls of one of the six large winches used for anchor and towlines. The towlines collided on deck and slid over the stern toward the *Yorkmar*. (Courtesy of Peter Marsh.)

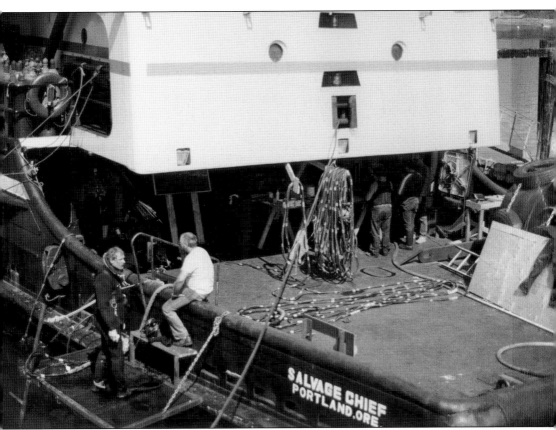

Here, the *Salvage Chief* is getting ready for another day's work. From retrieving lost anchors to helping free ships like the Exxon Valdez, the powerfully engineered ship has taken part in close to 250 operations since she began operating back in 1948. In the last 50 years, she has worked the waters between Panama and the Aleutians. The *Chief* was given a complete overhaul in 1980–1981, with a new bridge, electronic engine controls, hydraulic cranes, five GM generator sets, an additional machine shop, and a helicopter pad. More recent tugs carry much more power than those from after World War II. Several working together can successfully pull a ship off the sand and back into the channel upriver, a job that the *Chief* could achieve alone. But when it comes to a vessel grounded on the beach, even together, they will never compare to the 350-ton line pull the *Chief* can create with its anchors down and its winches turning. (Courtesy of Fred Devine Diving and Salvage.)

Devine began his first construction and salvage business in 1913, and Fred Devine Diving and Salvage Company is still active along the riverfront in Portland. It specializes in heavy marine salvage but offers a full range of underwater marine services. It provides fast response to any marine casualty, construction project, or major salvage operation. Salvage operations extend to Alaska, including the Aleutians and the Arctic Ocean, Canada, and the entire West Coast of the United States. Senior salvage master and president Mick Leitz, who worked as a diver and much more for Devine himself, has operated the company for many years. (Both courtesy of Fred Devine Diving and Salvage.)

Six

EARLY RECREATIONAL BOATING AND FISHING

A clean and clear Willamette River is the pride of Portlanders who fish, paddle, sail, swim, and explore its waters. The Willamette is a major tributary of the Columbia River, accounting for 12 to 15 percent of the Columbia's flow. The Willamette's primary downstream segment is 187 miles long, lying wholly in northwestern Oregon. Flowing northward between the Oregon coast and the Cascades Range, the river and its streams form the Willamette Valley, a basin that holds two-thirds of Oregon's population, including the state's largest city, Portland. Portland surrounds the Willamette's mouth to the Columbia River. Near this confluence north of downtown, the river splits into two channels that flow around Sauvie Island.

Between 1879 and 1885, the Willamette River was mapped by Cleveland S. Rockwell, a topographical engineer and cartographer for the US Coast Guard and Geodetic Survey. Rockwell surveyed the Willamette from the base of Ross Island, through Portland, to the Columbia River and then downstream on the Columbia to Bachelor Island, Washington. His work helped open the Port of Portland for trade and business.

Soon, boating became a popular pastime, as well as fishing. Fish in the Willamette River Basin include 31 native species consisting of cutthroat, bull, and rainbow trout; several species of salmon; and sucker, minnow, sculpin, lamprey, sturgeon, stickleback, and many others. With a day on the river, people found enjoyment catching their own breakfast or dinner on the Willamette right in downtown Portland.

Another exciting pastime, regardless of the cold and rainy days, was a series of races on the Willamette River. During the spring of 1908, a group of 15 motorboat-racing enthusiasts formed the Willamette Motor Boat Club, organizing boat races and numerous other activities. In May 1910, the club changed its name to the Portland Motor Boat Club. The name was changed again in 1925 to its present moniker: Portland Yacht Club.

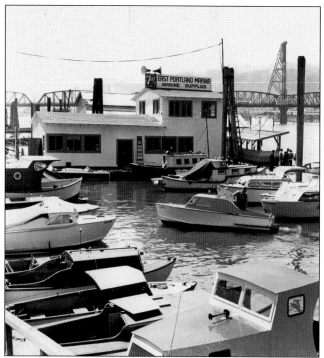

There was a time when building your own boat was a badge of honor. The photograph at left of the East Portland Marina is full of home-built boats, either constructed with plans from any of the popular magazines available at the newsstands or designed by the builder himself. In the background is Portland's Hawthorne Bridge. The photograph below casts the Steel Bridge in the background and the *Brest* in the foreground. Many of these boats were also custom-built, just not in Grandpa's workshop or garage. Both bridges are truss designs with a vertical lift. The Hawthorne opened in December 1910, while the Steel opened in July 1912. (Both courtesy of Peter Marsh.)

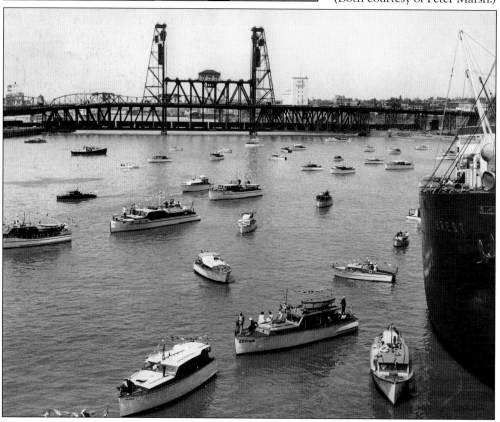

Portland maintains the largest population of sailboats in Oregon. Many sailors like to just cruise back and forth from the Interstate Bridge to the east end of Government Island. With the summer winds, it can be perfect for sailing upstream; one can tack all the way back. On a clear day, there are breathtaking views of Mount Hood and the Cascade Range. (Courtesy of Peter Marsh.)

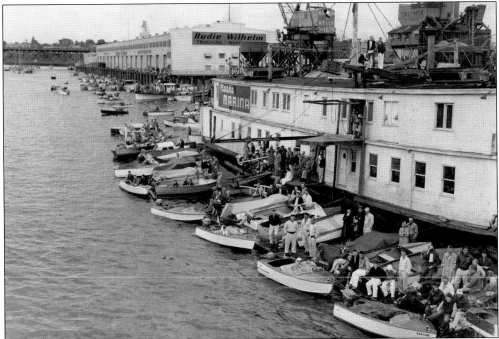

Outboard racing saw thousands of people participating and gathering along the shores of the Willamette River in downtown Portland. The family-owned-and-operated marinas were unpretentious and supplied the needs of fishing boats, sailboats, and powerboats. Rudie Wilhelm's, in the background, was a family food warehouse that began business in 1910 and later moved to the town of Milwaukie, Oregon, before closing in May 2008. (Courtesy of Peter Marsh.)

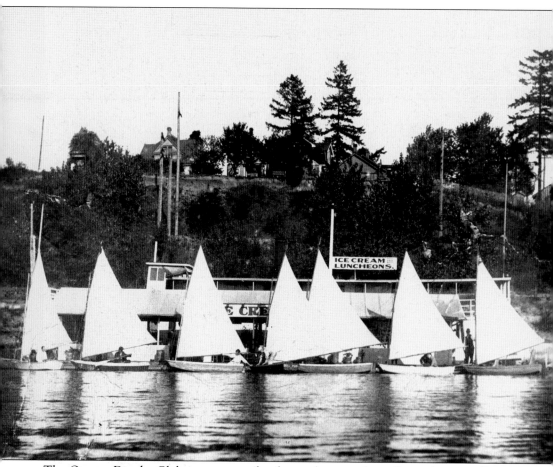

The Oregon Dinghy Club was a group for those who owned small one-design sailboats and enjoyed racing. These little boats had to be able to pass under the bridges of the Willamette River in Portland (18 feet overall was the largest craft that could race). The set path followed a triangular course, starting and finishing just off the Oregon Yacht Club pontoon. On January 9, 1911, braving a southeast wind that at times reached the height of a gale, three members of the Oregon Dinghy Club sailed twice on a one-mile course along the moorings at the Oaks. The *Butterfly*, owned and sailed by Lew Woodward, won this monthly race by a narrow margin. The *Bell Pup*, sailed by Francis D'Arcy, came in second, and the *Celt* and *Kitten* followed in that order. Later that morning, the second race took place along the same course, but it was a little slower. The *Butterfly* won again, followed by the *Celt* with Art Sholin at the tiller, then the *Bell Pup* and the *Kitten*. (Courtesy of Peter Marsh.)

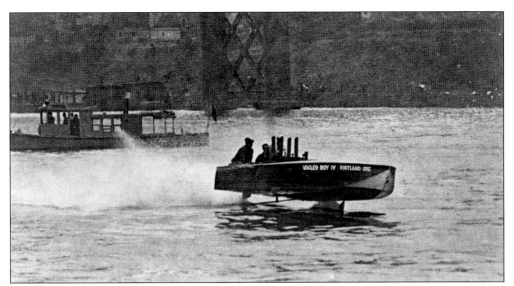

The Vogler brothers—Fred and Frank—had been building speedboats for years. They put their old Sterling engine from the *Vogler Boy III* into the 21-foot *Vogler Boy IV* and hit 65 mph during the 1921 Rose Festival Regatta, a part of the Portland Rose Festival, which is an annual civic festival held during the month of June in Portland. They were unbeatable until the 1923 Rose Festival, when the boat caught fire and burned. The Voglers safely jumped into the water and swam to shore. Another sporting sailor was Henry Dixon, who challenged seaworthy crafts with his experimental 32-foot-long *Dixie*, seen at right. Dixon is sitting in the engine compartment, while an unidentified fan poses behind him at the controls. (Both courtesy of Peter Marsh.)

By 1931, outboard motor racing had become a very popular sport. The Oregon Outboard Association began sponsoring race activities that brought in thousands of spectators. The races of May 1933 were set at the south end of Jantzen Beach Park, Hayden Island, on the Columbia River. The crowds went wild watching some of the fastest boats in the area challenge each other in this all-day event. The winner was none other than the *Vogler V,* shown at left with Fred at the helm and brother Frank behind him. Ron Loomis (below right), who won his race, is seen with Harry Woods holding the boat. (Both courtesy of Peter Marsh.)

The *Argus* was a 51-foot homemade motor yacht built in Portland in 1934. It took 27-year-old Jack R. Hunt (inset) eight years of his savings and five years of labor to create his perfect cutter using blueprints that he had drawn himself. He launched the *Argus* from Portland, heading to Oakland, California, with his wife Evelyn, his toddler son Richard, and his 18-year-old friend Robert Upson as crew. Hunt had been the circulation manager of the Portland newspaper, the *Oregonian*. During all that time, he was saving his money to make his dream boat. He had built 13 small hulls and practiced racing boats. Although he had never sailed on the high seas, he had studied celestial navigation so he could plot his yacht's course by the stars. In 1937, Captain Hunt took his wife, two sons, and a four-man crew and sailed south to Los Angeles, then on to Honolulu. Fighting the swelled waves of the sea, it took the battered boat 22 days to safely return to a San Francisco harbor. (Courtesy of Peter Marsh.)

In 1942, a group of 31 graduates of the first US Power Squadron piloting course met in Portland to organize a new squadron, becoming the Portland Sail and Power Squadron. (The US Power Squadrons are a civilian membership establishment dedicated to promoting boating safety.) World War II had already started, and many squadron members joined the armed forces. One of the main charter members of the Portland Squadron was Larry Barber, who, in his many years as a squadron member and journalist for the *Oregonian*, promoted the Power Squadron throughout the community. The group has dwindled over the years but is still active in Portland. Pictured above are Larry and wife Elizabeth in their boat the *Rambler*. The photograph at left shows Larry with another fine catch. (Both courtesy of Peter Marsh.)

Even today, the Willamette River provides some of the best fishing; it has some of the greatest sturgeon and spring chinook salmon fishing anywhere. The Willamette is home to large runs of spring chinook salmon, locally known as "springers" or "spring kings." A typical springer weighs an average of 15 to 20 pounds, but they often exceed 30 pounds. The Willamette River is truly an exceptional fishery; a fisherman can catch salmon, steelhead, and giant sturgeon, all in one place and right in downtown Portland. Above, the immense size of a sturgeon is apparent, as it takes a few men to handle, and at right, a young girl is seen smiling coyly as she stands next to a salmon as tall as she. (Both courtesy of Peter Marsh.)

Some time ago, open streams ran across downtown Portland and the Northwest Industrial area. Tanner Creek flowed into a swampy area called Couch Lake, which reached from just south of the Steel Bridge to the Fremont Bridge but was filled in, bit by bit, between 1896 and 1919. Other creeks were diverted into the sewer system and their streambeds filled to make room for expansion of Portland. An old cut-off bend of the Willamette River called Guilds Lake was filled for industrial expansion. Above, the Willamette River was, and still is, the most popular place to fish. It hosts runs of Shad, good sturgeon fishing, walleye and smallmouth bass fishing, and migrating salmon. Many folks also enjoy just taking scenic trips up and down this popular waterway. Below, the YMCA launches a day trip for families. (Both courtesy of Peter Marsh.)

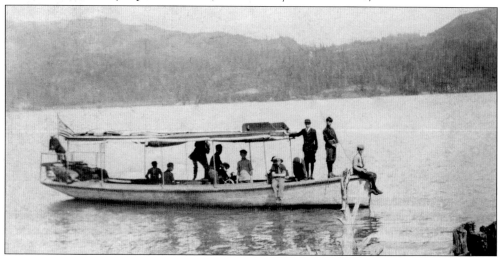

For these early Portlanders, fishing on the Willamette was often a way of life or how they kept their families fed. Professional fishermen did, and still do, make a living plying the Willamette and the Columbia. Still, for those men who didn't fish for trade, local fishing derbies have always been popular. Prizes were usually awarded for the most fish caught, generally of the same species, and also for the largest fish. Prizes could be monetary, a shiny trophy or plaque, some new fishing gear, or even a household appliance. Sometimes, in an informal gathering, it was simply bragging rights. (Both courtesy of Peter Marsh.)

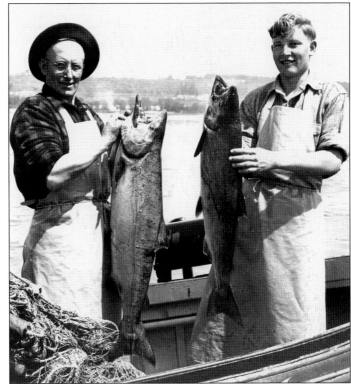

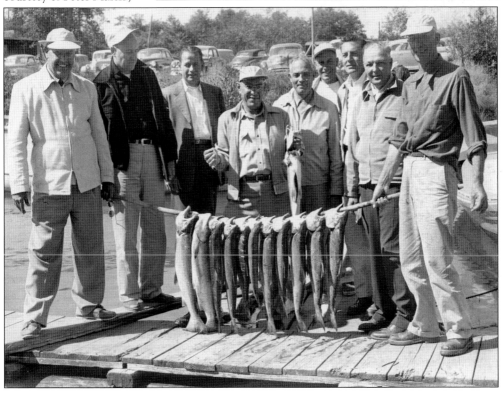

Discover Thousands of Local History Books
Featuring Millions of Vintage Images

Arcadia Publishing, the leading local history publisher in the United States, is committed to making history accessible and meaningful through publishing books that celebrate and preserve the heritage of America's people and places.

Find more books like this at
www.arcadiapublishing.com

Search for your hometown history, your old stomping grounds, and even your favorite sports team.